IMAGES
of America

ENCINITAS

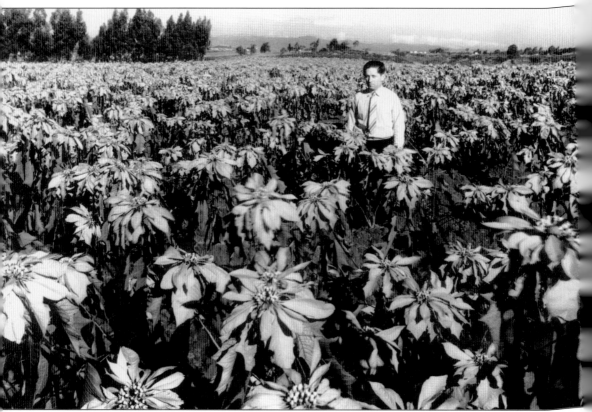

ON THE COVER: Taken in the 1940s, this photograph shows Paul Ecke Sr. surrounded by a field of *Euphorbia pulcherrima*, more commonly known as the poinsettia. In 1970, Paul Sr. was elected into the Floriculture Hall of Fame of the Society of American Florists. More than any other person, he has made the poinsettia a worldwide phenomenon, gaining fame for Encinitas to be known as "The Flower Capital of the World." (Courtesy of the Ecke family.)

IMAGES
of America

ENCINITAS

Kenneth M. Holtzclaw and Diane Welch

ARCADIA
PUBLISHING

Copyright © 2006 by Kenneth M. Holtzclaw and Diane Welch
ISBN 978-0-7385-4665-0

Published by Arcadia Publishing
Charleston SC, Chicago IL, Portsmouth NH, San Francisco CA

Printed in the United States of America

Library of Congress Catalog Card Number: 2006925994

For all general information contact Arcadia Publishing at:
Telephone 843-853-2070
Fax 843-853-0044
E-mail sales@arcadiapublishing.com
For customer service and orders:
Toll-Free 1-888-313-2665

Visit us on the Internet at www.arcadiapublishing.com

To Wendy Haskett

CONTENTS

ACKNOWLEDGMENTS

Retracing the roots of Encinitas has been an intriguing journey for the authors. Full of twists and turns en route, the passing landscape that emerged showed a rich heritage with many fascinating stories from equally fascinating people.

Without the access to historical archives and photographic collections, the authors, instead, sought out the descendants from notable families and gathered valuable information and photographic images directly from the people themselves. Their stories have been recorded for posterity and will be used in future publications. However more than anything, their generosity, time, grace, and good humor have made this journey a memorable one. Our lives have been enriched by meeting and getting to know the citizens who are Encinitas.

The following acknowledgments represent a heartfelt THANK YOU to each individual that made this book possible: Dan Dalager, Fred Caldwell, Don Hansen, Mary Beth Hayashi, Evelyn Weidner, Ken Hayward, Bob and Jan Grice, Kim and Betty Daun, Woody Ekstrom, John Elwell, Linda Benson, John Kentera, Keith Turner, Sherry Smoot, Jim Gilliam, Gerry Sova, Dody Tucker, Heidi Prola, Joyce Mizock, Lenore Dale, Tony Hawk, Gordon Haskett, Edith Fine, Dorothy Waldorf, Lauren Landress of the Self Realization Fellowship, John McIsaac, Henry Traulsen, Rick Shea, Jim Curl, the Solana Beach lifeguards, Stephanie Cashion, Mark Anderson, Lola Larson, Tim Williams (G.I.S. analyst of Encinitas City), Scott Smith (owner of 101 Diner), and Barbara Winter. We are especially grateful to the following people who provided their family albums for our perusal and gave generous rights for the publication of their treasured collections: Harley Denk and Mary Beth Hayashi, Dave and Bertha Young, Jimmy and Betty Brass, Lynwood Cole, Richard Scott, Roger and Jeanette Teten, and a very special thank you to the Ecke family for the use of their never-before-published vintage images. A chapter has been devoted to a sampling of these wonderful period photographs. Thanks also go to Maggie Houlihan for her encouragement, her guidance, and her advice to "never, ever give up!" And on a final note, we would like to say "Happy Birthday" to the city of Encinitas.

INTRODUCTION

The five communities that comprise the city of Encinitas are like siblings from a family. Their father maintains old-fashioned values and is hardworking and disciplined, while their mother is nurturing, young spirited, and loving. Their children are a blend of the two. The duplicity that defines the unique nature of this fine city can be seen in the landscape, the architecture, the culture, and the people. It is the mix, not the match, which unites Encinitas.

The year 2006 is a landmark anniversary for this California coastal enclave, which will be celebrating 20 years of city hood. Nestled between two coastal features, the Batiquitos Lagoon to the north and the San Elijo Lagoon to the south, Encinitas epitomizes the Southern California culture. Artists, writers, surfers, and musicians stand shoulder to shoulder with business owners, floriculturists, farmers, and dreamers. Each has left a mark on their community, and each is a vital brush stroke in the portrait of the region.

The five communities have retained their individuality, and each community is a reflection of its history. To the south, Cardiff-by-the-Sea was settled by a Scottish immigrant, Hector Mackinnon, who fought in the Civil War. In 1875, he homesteaded 600 acres on the north side of San Elijo Lagoon on what some then considered worthless land. Mackinnon ignored the negative opinions and was successful in raising livestock and produced milk, butter, and fine fruit jellies. However this produce was not enough to sustain his family, and Mackinnon resorted to selling off part of his land. When developer Frank Cullen arrived there in 1911, he purchased part of the Mackinnon Ranch and introduced an English accent by naming the streets for notable British cities such as Manchester, Birmingham, and Liverpool. His wife chose the name Cardiff as a tribute to the pretty Welsh City. He built a 300-foot pier and a majestic building, the Cardiff Mercantile Company, which is reminiscent of Victorian English seaside architecture. Once home to a large kelp works plant, the coastal community now provides perfect surfing conditions at Cardiff Reef and is the venue for annual amateur and professional surfing competitions.

At the northern end of Encinitas lies Leucadia, considered by some to predate the founding of Old Encinitas by several years. It is said that British spiritualists settled in Leucadia around 1870 and romantic folklore has them dancing in Roadside Park wearing flowing white robes. They named the streets for Greek gods, like Vulcan and Diana, and chose the name Leucadia as it meant "sheltered paradise" in Greek. The stretch of Leucadia that runs along Highway 101 harkens back to the 1880s when noble Eucalyptus trees were planted to create a positive energy. The trees still grace this beautiful stretch of unspoiled highway. The residents of Leucadia are proud of this historic past and have maintained an identity that has not been marred by big box buildings and generic architecture. Their car bumper stickers and license plate frames urge people to "Keep Leucadia Funky."

In the 1920s, after Hodges Dam was constructed and water was piped into the area, flower growers began to settle in the region. As Los Angeles began to be developed, floriculturists there moved south to Leucadia and Encinitas, and greenhouses and flower fields began to dominate the landscape. Soon the region was a patchwork quilt of colored blooms. While many of the flower

growers have since disappeared, there are still several small businesses that maintain a presence, including Weidner Begonia Gardens and Cordova Nurseries. Through four generations, the Ecke family has been working the land. When Paul Ecke Sr. moved his poinsettia ranch south from Hollywood to Encinitas in 1920s, the area became known as the "Flower Capital of the World." The poinsettias were field grown and produced a dramatic red canvas that dominated their vast acreage. By 1963, though, new varieties of poinsettia were being grown in greenhouses, which would ultimately change the flower business and the landscape. The Ecke family has been a part of Encinitas for over 80 years. They have been philanthropic benefactors to the citizens of Encinitas, donating land for the YMCA and other local organizations and providing employment for local residents.

Four miles east of historic Moonlight Beach, Colony Olivenhain was established in 1884. Newspaper advertisements published in Colorado promised verdant land, abundant crops, and an idyllic life for German immigrants, but the reality was quite different. The lack of water and the dry climate on this former Spanish rancho, Los Encinitas, forced many colonists to give up and just leave. Those who stayed and wrestled with the environment found a living by dry farming lima beans; raising cattle, turkeys, and chickens; and growing wheat, barley, and oats. Today Olivenhain is an upscale community with spectacular homes nestled on large lots and spectacular views that would feel right at home on the front page of *Architectural Digest*.

When tracks of the California Southern Railroad Company made their northerly journey from National City, Encinitas was considered largely uninhabitable due its barren coastal landscape. However nearby Cottonwood Creek provided water for the steam locomotives, and when a water tower was built, it became a scheduled whistle stop for the steam engines. Railroad crews, mostly Chinese and housed in tents, lived on the land, and by 1881, historic downtown was established. Thomas Rattan was sent by the railroad company to choose a location for the train depot and to survey the immediate land to develop a township, which he laid out in the classic grid system. Some of the first settlers to arrive were the Hammonds, English immigrants who doubled the population (excluding the Chinese labor) when the 11 of them stepped off the train and decided to stay despite the apparent false promises that had lured them there. The train depot was completed in 1887, and First Street became the main road through the township. It would later be known as Coast Highway 101.

The fifth community—the metaphorical baby of the family—is New Encinitas, ironically named as its historic roots reach far into the past. Located east of Interstate 5, it is centered on El Camino Real between Encinitas Boulevard and Leucadia Boulevard in an area once known as Green Valley and is dominated by the Encinitas Ranch Golf Course located at 1275 Quail Gardens Drive. It is a vibrant, successful commercial district with upscale shopping centers, restaurants, and entertainment. It symbolizes the forward vision of Encinitas and looks ahead to a continued fiscally healthy city.

From the pioneer Hammond family to famed skateboarder Tony Hawk, Encinitas is a notable city with memorable citizens. It can be proud of its roots and gain strength from its early settlers. It is a city that represents a past of struggle during the pioneer years, hardship during the Depression years, and tremendous growth during the postwar years. It is now a vital, energetic city, a wonderful community to raise a family, and a spectacular place to live. A city with a small-town feel, its history continues to be written.

One

ENCINITAS PAST

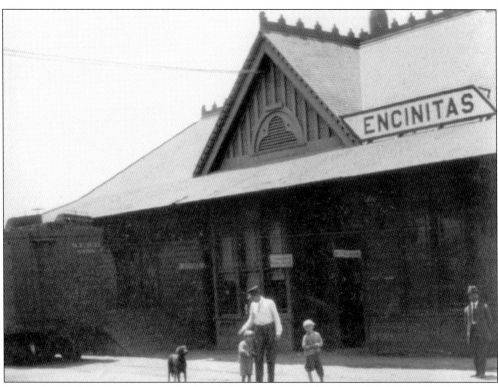

It was the California Southern Railroad Company that helped establish historic downtown Encinitas in 1881. The Encinitas train station, pictured here in the 1900s, was established and built in 1887. Initially just a water stop for the steam engines, it evolved into the core of the newly developing township. (Courtesy of Quail Botanical Gardens.)

This c. 1920s photograph shows Vulcan Avenue, a road that runs like a ribbon from Leucadia to Cardiff. Looking south, it is notable that there are no visible buildings from this vantage point. The railroad tracks can be can be seen on the right. The dip in the road may be a bridge that originally went over Cottonwood Creek. (Courtesy of Quail Botanical Gardens.)

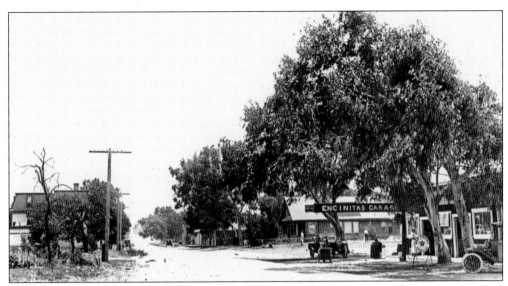

The Lux Brothers, Peter, John, and Henry, immigrated to the United States from Luxembourg in the 1880s. This 1916 photograph shows how First Street looked back then with the home of Peter Lux on the right, located behind the Encinitas Garage. In 1882, Peter Lux married Margareth Cloud; they had five children and were successful in both lima-bean farming and beekeeping. The Pitcher House is the building on the left. (Courtesy of Quail Botanical Gardens.)

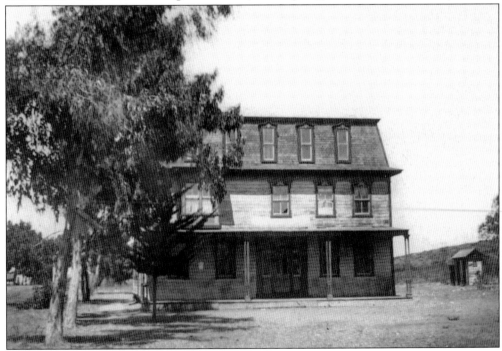

The Encinitas Hotel was built by Edward G. Hammond in 1883. Originally known as the Pitcher House for one of the town's founders, it was located at 575 First Street. Business was slow in the beginning, but the hotel would soon become the centerpiece for the community. As soon as the floors were laid, word was sent to the ranchers to come help celebrate the occasion with an all-night dance. (Courtesy of Bob and Jan Grice.)

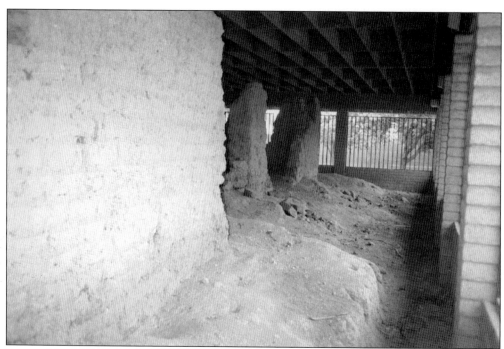

Pictured here are the remains of Ybarra's adobe ranch house on Rancho Los Encinitas that comprised 4,431 acres. Still extant, the decaying adobe ruins are presently protected with fence and cover. In 1842, it was the home of ranch owner Andres Ybarra. The Ybarra ranch house became a stage station in the 1880s, while today it has been preserved as Stagecoach Park. (Courtesy of Ken Holtzclaw.)

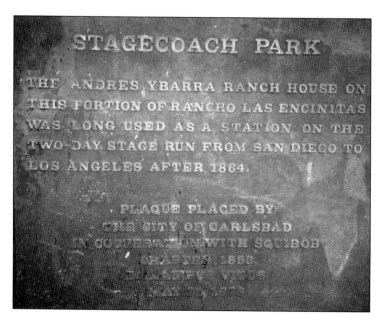

Representing the remains of the Ybarra ranch house, this plaque indicates that the house was once located on Rancho Los Encinitas and used as a station stop on the two-day stagecoach trip from San Diego to Los Angeles after 1884. The area has now been incorporated into a park just a few miles northeast of the heart of today's Encinitas. (Courtesy of Ken Holtzclaw.)

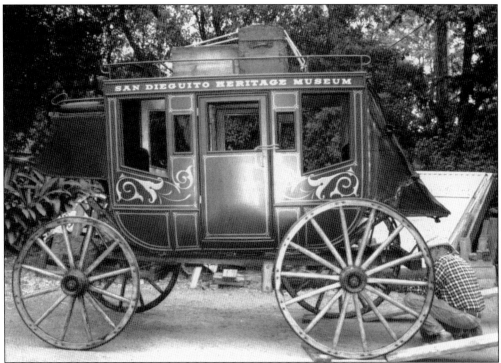

This stagecoach was skillfully renovated by longtime Cardiff resident and local history enthusiast Dave Young, pictured here at right. With the help of some willing volunteers, he faithfully reconstructed the original beauty of this 1880s state-of-the-art mode of transportation. The coach was featured in the 2004 Encinitas holiday parade. (Courtesy of Dave and Bertha Young.)

The house at 2019 Manchester Avenue is better known as Cardiff's Stones House. Originally a Wells Fargo stage stop, it was bought in the 1920s by Preston and Annie Bea McChesney who lived there with their six children. (Courtesy Ken Holtzclaw.)

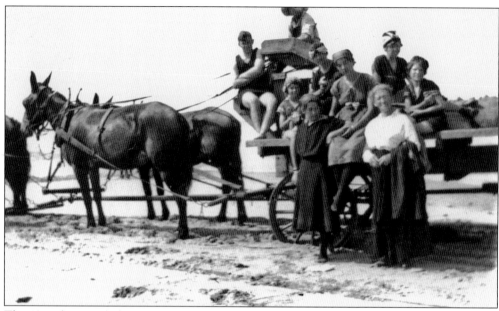

This 1912 photograph shows Sam Hammond and members of the Van Antwerp and Cozens families returning from Cottonwood Creek. The rain cistern at the Hammond's home, Sunset Ranch, had run dry, so barrels of water had been collected from the creek. As some in the photograph are wearing swimsuits, it appears that the outing also included a stop at nearby Moonlight Beach. (Courtesy of Bob and Jan Grice.)

This photograph shows the Encinitas Ranch Golf Course, an 18-hole, par-72 course with panoramic views of the ocean. Constructed on the original site of the Hammond's Sunset Ranch, it retained some of the initial ranch features, incorporating them into the design of the course. A dramatic elevation change throughout the course provides a challenge for golfers. (Courtesy of Ken Holtzclaw.)

"Water on our coast lands is surely the blood of the soil," wrote Col. Ed Fletcher, a local land developer, in his memoirs of 1952. By 1918, Hodges Dam, which he was instrumental in initiating, was completed. Following the formation of the San Dieguito Mutual Water Company, water was finally piped into Encinitas by 1923. (Courtesy of the Denk family.)

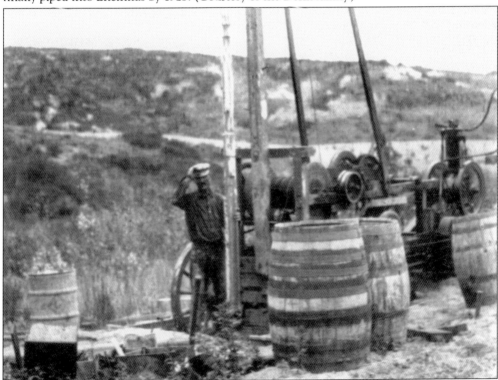

Before piped water, ranchers used creative measures to irrigate land, water cattle, and sustain their families. This 1911 photograph, taken at the Scott Ranch in Green Valley, shows how farmers drilled for water and stored it in huge barrels. (Courtesy of the Scott family.)

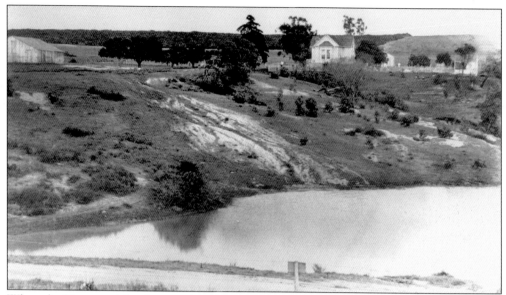

When the Hammond family arrived in Encinitas in 1883, it is said that this party of 11 doubled the township's population. Originally from Macclesfield, Cheshire, the English family settled at Sunset Ranch, pictured here, moving in before the windows and doors were hung. Located at the east end of what is now Leucadia Boulevard, it was a large, well-appointed structure and became the hub for local social gatherings. (Courtesy of Bob and Jan Grice.)

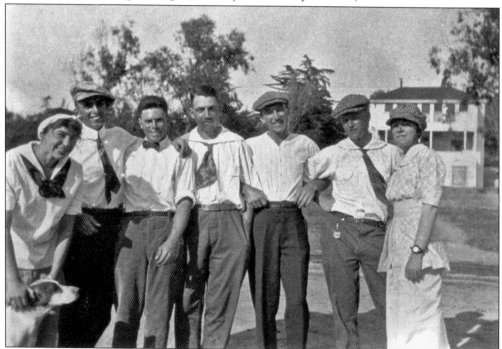

This Hammond family photograph, taken in 1916, shows the Derby House in the background. Another local landmark, Edward G. Hammond built this home, located on Vulcan Avenue, for Amos Derby in 1887. Conveniently located across from the train depot, it is still extant and continues to be used as a residence. (Courtesy of Bob and Jan Grice.)

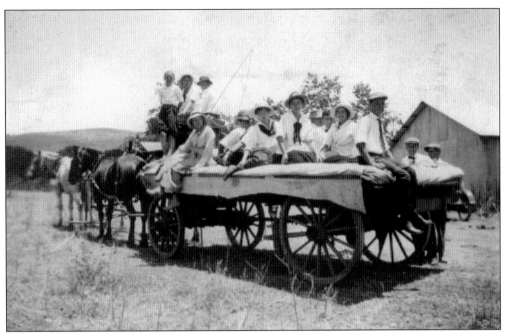

Before the mass production of the automobile, families could travel comfortably en masse as pictured in this Hammond family 1916 photograph. Idyllic settings and the mild California climate provided the perfect conditions for family outings to the backcountry or to the beach. (Courtesy of Bob and Jan Grice.)

This photograph shows the one-room schoolhouse built by E. G. Hammond in 1883. The oldest extant building in Encinitas, it originally faced eastward toward downtown. In 1927, it was moved to Fourth and H Streets and was converted to a home. In the 1980s, it was returned to its approximate original location. (Courtesy of Ken Holtzclaw.)

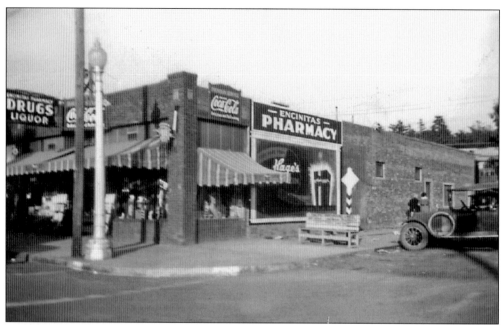

By 1930, the population of Encinitas had swelled to 778, and, as in many developing towns, the local drugstore became a community gathering place—Encinitas had several. This photograph shows the Encinitas Pharmacy, located on the northeast corner of First and E Streets, which competed with nearby Claydon's Pharmacy. (Courtesy of Bob and Jan Grice.)

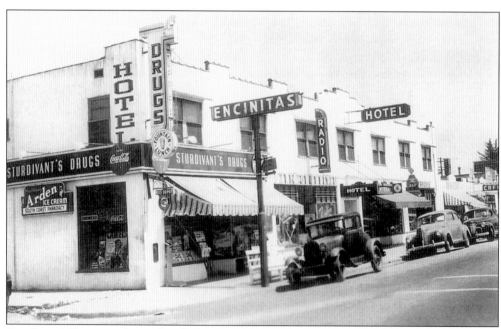

Sturdivant's Drugs was located at the corner of First and D Streets below the Encinitas Hotel. By the late 1930s, the store, owned and operated by John Sturdivant, not only provided pharmaceutical items, cosmetics, and general merchandise but also had a soda fountain, a lunch counter, and sold beer. (Courtesy of Bob and Jan Grice.)

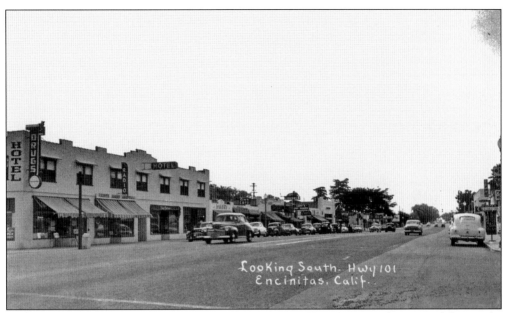

This image of Highway 101 harkens back to the unspoiled beach towns that existed during the decades prior to the 1960s. Note the north-traveling 1948 Ford Coupe, which helps date the scene. Today downtown Encinitas still has the feel of earlier times and has retained its beach and art culture. (Courtesy of Bob and Jan Grice.)

The original Encinitas sign, similar to the one pictured here, spanned Highway 101 from 1928 to 1937. In celebration of the 14th year of the city of Encinitas's incorporation and the millennium year, a replica was installed. In October 2000, it was dedicated to the citizens of Encinitas by the Downtown Encinitas Mainstreet Association. (Courtesy of Ken Holtzclaw.)

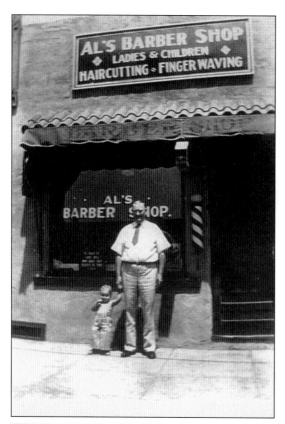

Taken in 1933, this photograph shows Grant Ulysses Johnston with his granddaughter Harveen standing outside Al's Barber Shop, located at 569 First Street. In 1920, Johnston won the haircutting business in a lucky game of cards. Overnight he became a barber and was so thrifty that he kept Al's sign on the storefront, adopting the name for himself rather than change the sign. (Courtesy of Harvey Johnston family.)

This *c.* 1920s photograph of "Al" giving a customer a haircut shows the no-frills decor back then. However service was first-rate, and Al, with his son Harvey, also known as Al Jr., would often barter haircuts for food, particularly during the Depression era. (Courtesy of Harvey Johnston family.)

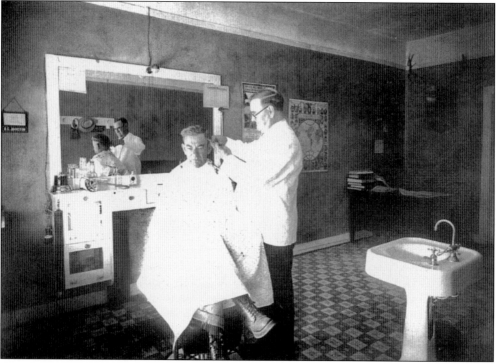

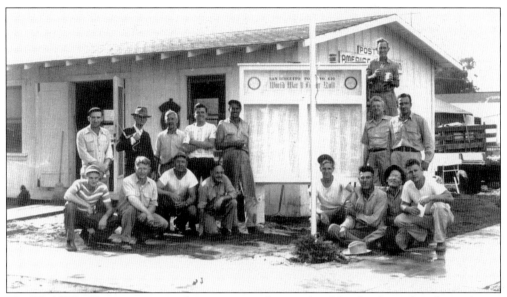

The World War II years represented a grave era, with many local families losing loved ones during the war effort. This 1946 photograph shows servicemen outside of the American Legion, Post No. 416, still located at Second and F Streets in downtown Encinitas. The organization is still vibrant and is a source of social activity for members who can enjoy bingo and hearty, inexpensive meals there. (Courtesy of John Kentera.)

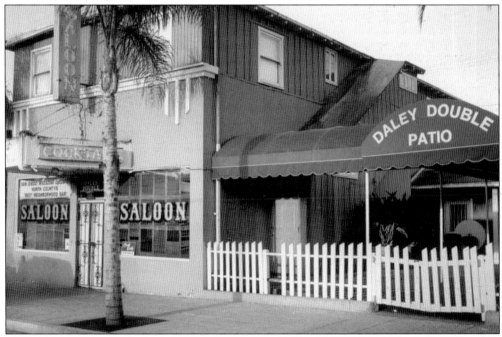

The Daley Double Saloon evolved from the Maurice DeLay's 1930s Village Rendezvous. An alert button can still be seen at the end of the bar, a throwback to when an illegal poker parlor operated in the upstairs quarters. There was boxing outside on the patio on Friday nights, paying $5 to willing contestants. The business became the Grand Café in 1942 and then the Daley Double in 1956 when Ruby and Frank Daley purchased the property. (Courtesy of Ken Holtzclaw.)

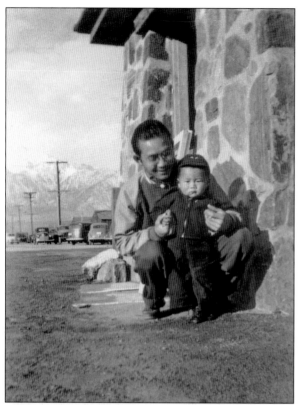

As well as losing loved ones during World War II, many local residents were forced to leave the region by the Civilian Exclusion Order No. 4 in April 1942. Japanese residents had to abandon their homes, their belongings, and their friends when they were placed in relocation camps. This 1943 photograph shows Kat Hayashi with his 13-month-old son Ronald outside the guard post at the Manzanar Camp. (Courtesy of Mary Beth Hayashi.)

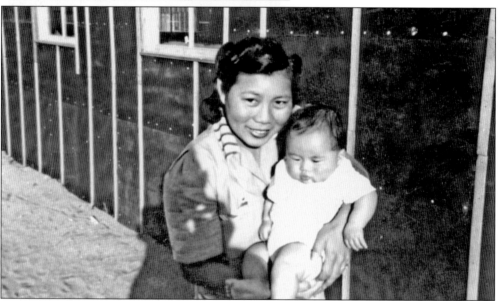

Ronald Hayashi was only a few months old when his family was relocated to the Manzanar Camp at Owens Valley in 1942. This photograph of the same year shows him with his mother, Yukie Hayashi. Despite the sparse living conditions, the Hayashis were able to befriend the guards, who gave Kat Hayashi a fishing pole, enabling him to provide extra nourishment for his wife, Yukie, who was expecting their second child. (Courtesy of Mary Beth Hayashi.)

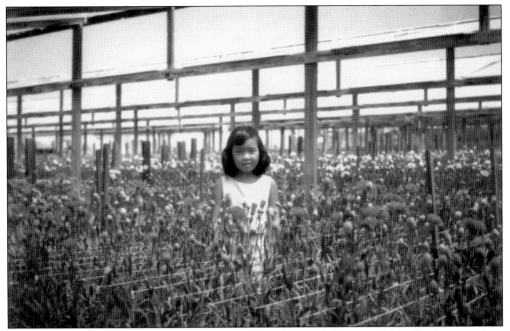

Nine-year-old Vickie Hayashi provides a focal point in this 1965 photograph showing the carnations grown by the Hayashi family. The local floriculture industry was initially developed by people like Thomas F. McLoughlin; the Ecke family, famed for their poinsettias; Elmond G. Thornton; and Donald Briggs. (Courtesy of Mary Beth Hayashi.)

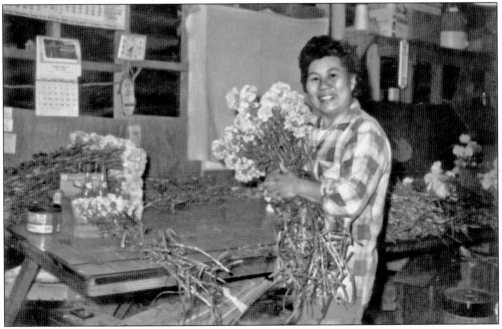

Flowers have been synonymous with Encinitas since the mid-1920s, when the soil proved to have rich loam and the moderate climate made ideal growing conditions. This 1965 photograph shows Yukie Hayashi preparing bouquets of her carnations grown at the family's nursery on Lake Drive in Cardiff. (Courtesy of Mary Beth Hayashi.)

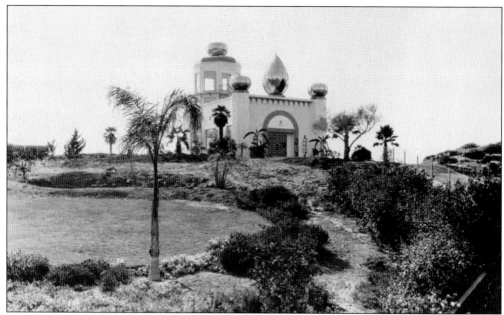

In 1937, during his absence, faithful disciples built a hermitage for Paramahansa Yogananda. The magnificent Golden Lotus Temple, pictured here, was constructed on the edge of the bluff that same year. The Self-Realization Fellowship Retreat and Hermitage Center stands on the site originally known as Noonan's Point. Overlooking Swami's Beach, the 17-acre site attracts worldwide visitors who enjoy its beautiful gardens and magnificent views. (Courtesy of the Self Realization Fellowship, Los Angeles.)

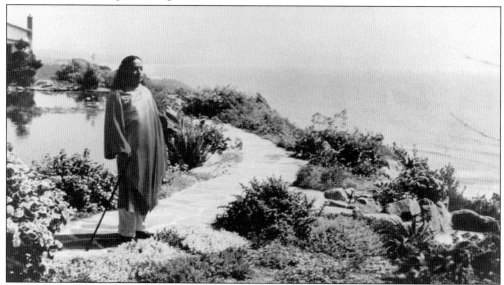

In 1893, Paramahansa Yogananda was born Mukunda Lal Ghosh in Gorakhpur, India. When he was 27, he founded the Self Realization Fellowship to spread his philosophies on yoga and meditation. During his years at his hermitage in Encinitas, he penned *Autobiography of a Yogi*. It has been in print continuously since it was published in 1946 and has been recognized as one of the 100 best spiritual books of the 20th century. (Courtesy of the Self Realization Fellowship, Los Angeles.)

Known as the "Iron Butterfly," Ida Lou Coley, a longtime Encinitas resident and former San Dieguito Union High School cheerleader, became a much-loved local historian. Her *joie de vivre* was captured in this historic shot taken at Swami's Beach in 1945. It was recently included on the City of Encinitas's commemorative calendar in memoriam of Ida Lou, who passed away in 2005. (Courtesy of Heidi Prola.)

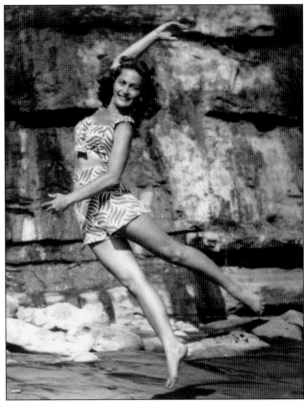

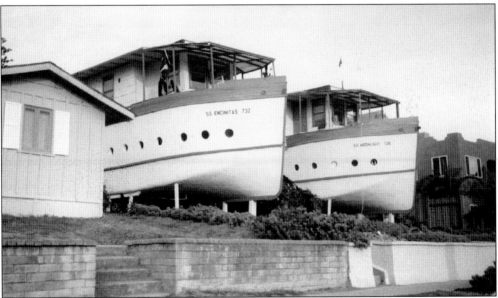

Miles Minor Kellogg was a builder and inventor who would later be considered the ultimate recycler. In 1925, he salvaged wood from the dismantled dance hall at Moonlight Beach. The lumber's short length led Kellogg to create the pair of boathouses, the SS *Encinitas* and the SS *Moonlight* in 1928. Located at 726 and 732 Third Street, they symbolize the beach and surfing culture that dominates the coastal area. (Courtesy of Ken Holtzclaw.)

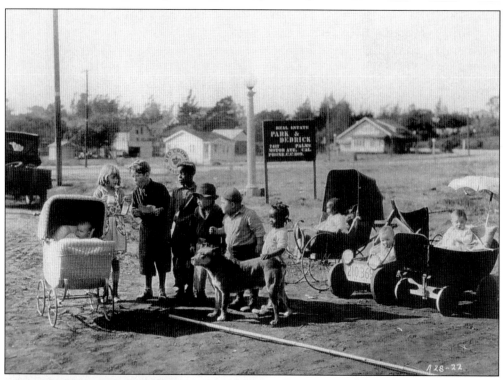

Encinitas resident Lola Larson lived and grew up on-site at the Hal Roach studios in Culver City. Her father was a scout and cameraman for his brother, legendary movie director Hal Roach. As a baby, Lola was often cast in non-speaking parts, as seen here in this 1922 photograph with the cast of *The Little Rascals*, a Hal Roach phenomenon. She was the baby in the pram at left. (Courtesy of Lola Larson.)

The most memorable night in downtown Encinitas history was when *The Cohens and Kelleys in Paris* was staged at the La Paloma Theater. Movie stars sat shoulder to shoulder with locals, when on February 11, 1928, the first ever "talkie" was screened at the theater. The star-studded event was attended by Hollywood's darling, Mary Pickford, who lived at nearby Fairbanks Ranch with husband Douglas Fairbanks. (Courtesy of Ken Holtzclaw.)

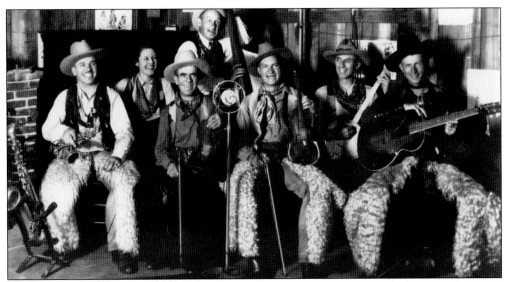

This late 1930s photograph shows the Encinitas Ranch Hands, a popular band during the 1930s and 1940s. Pictured here, from left to right, are (first row) D. M. MacFarland, saxophone; Charles Brass, violin and musical saw; Neil Conrad, fiddle; and Burt Milholland, guitar; and (second row) Gertrude MacFarland, piano and vocal; Lloyd Nay, base fiddle; and Lyle "Beak" Hammond, banjo. (Courtesy of Jimmy and Betty Brass.)

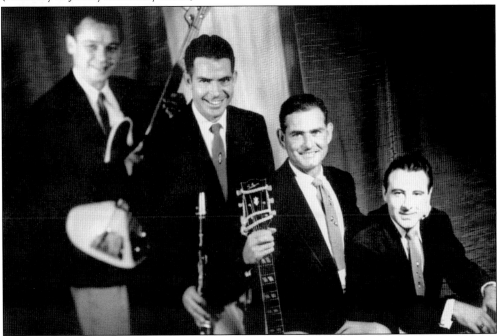

This photograph of the Four Harps includes, from left to right, bassist Bill Evans, clarinet player Jimmy Brass, guitarist Wayne Smith, and vocalist and accordionist Eddie Chini. The Encinitas-based quartet began performing together in 1953. One of their longest engagements was at the North Island Naval Air Station, where they regularly performed during a seven-year period. By their retirement in 1983, they had completed 30 years as professional entertainers. (Courtesy of Jimmy and Betty Brass.)

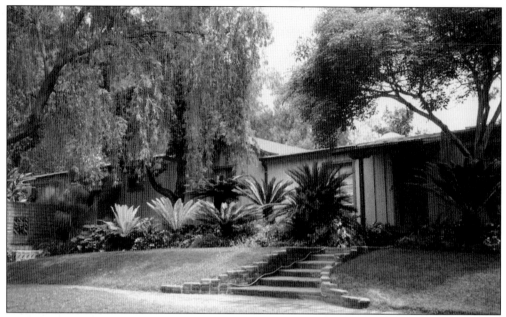

This is a view of the front of the Ruth Baird Larabee House in Quail Botanical Gardens, originally called El Rancho de las Flores. In 1957, Mrs. Larabee, who owned the grounds, deeded 25 acres, including the residence, to San Diego County with the stipulation that a botanical garden be created there and that groundskeepers live in the home. (Courtesy of Ken Holtzclaw.)

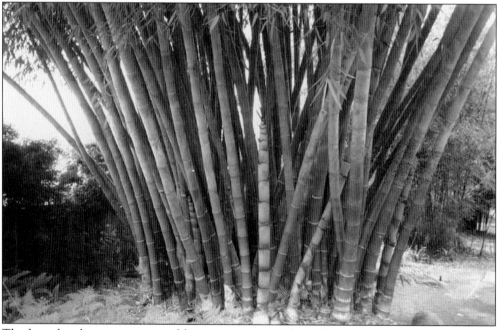

The large bamboo canes pictured here are one example of the extensive number of bamboo varieties grown in the 39-acre Quail Botanical Gardens. There are 100 varieties of bamboo alone cultivated. Ruth Larabee traveled extensively, collecting plants that would thrive on her estate. Currently there are 3,000 plants showcased in QBG's extensive 25 gardens. (Courtesy of Ken Holtzclaw.)

This is a photograph of a large cork tree, a 50-year-old specimen that stands today in the Cork Oak grove at the Quail Botanical Gardens. During World War II, the supply of cork from the West Indies was threatened. The government encouraged the experimentation of cultivating cork trees and several remain. (Courtesy of Ken Holtzclaw.)

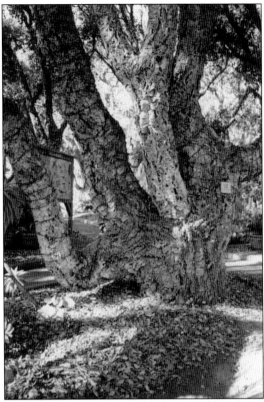

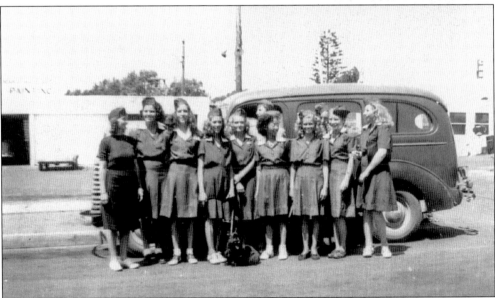

Miki Nagata recently donated this 1946 photograph to Quail Botanical Gardens. The Larabees were civic-minded individuals who supported the Boy Scouts and Camp Fire Girls organizations. Pictured here are eight Camp Fire Girls and their troop leader getting ready to embark on one of many camping expeditions headed up by the Larabees. Miki Nagata is fourth from the right. (Courtesy of Quail Botanical Gardens.)

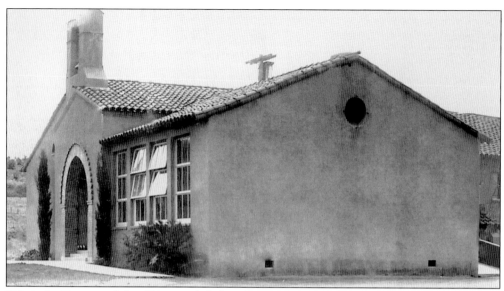

When the Encinitas School District failed to obtain a majority of votes to fund new buildings in 1927, a bond was passed that resulted in Central Elementary School being constructed by the fall of 1929. This 1932 photograph shows details of the school that is still located on Union Street in Leucadia, now known as Paul Ecke Central School in memory of Paul Ecke Sr. (Courtesy of Jimmy and Betty Brass.)

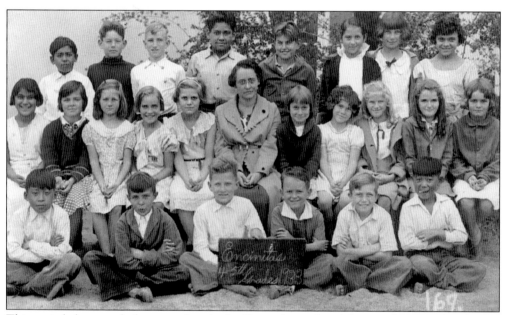

This period photograph shows teacher Azalea Young (center) with her combination fourth- and fifth-grade class at Central School. Taken in 1933, it illustrates the diversity of students during that era. It was not unusual for children to attend school barefoot, as evidenced by the children seated in the first row. (Courtesy of Dave and Bertha Young.)

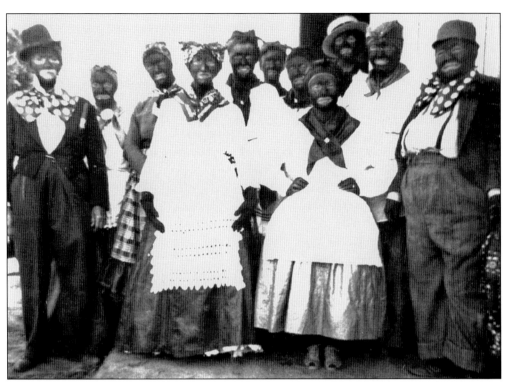

In 1942, parents, teachers, and children at Central Elementary School collaborated in staging a lively minstrel show in the school's cafeteria. This photograph captured some of the cast members of the show illustrating the community's involvement in their children's education and recreation. (Courtesy of Dave and Bertha Young.)

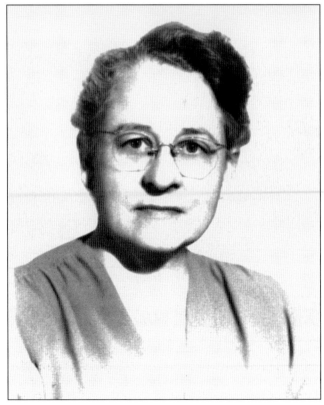

Azalea Young was a much-loved teacher at Central School. Beginning her tenure in 1932, Azalea, with prior teaching experience at schools in San Felipe, Pala, and then one year at Pacific View Elementary, taught at the local school until her retirement after 24 years of service. (Courtesy Dave and Bertha Young.)

Herschell Larrick Sr., a resident of Solana Beach and owner of the Lumber and Builders Supply Company, was instrumental in forming the San Dieguito Union High School District along with Annie Cozens. Together they worked to get funding for the much-needed high school. Designed and built in 1937 by local architect Lilian J. Rice, it officially opened to students in January 1938. (Courtesy of Charles Larrick.)

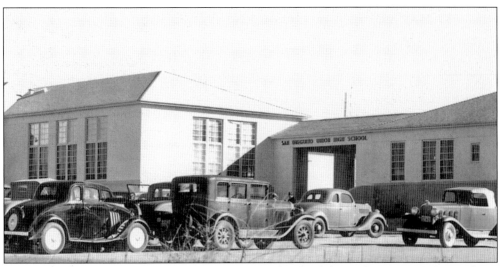

This 1938 photograph of the San Dieguito Union High School, located on Santa Fe Drive, shows the main entrance to the school campus. Today the school, now known as the San Dieguito Academy, is one of six high schools in the San Dieguito Union High School District. (Courtesy of Jimmy and Betty Brass.)

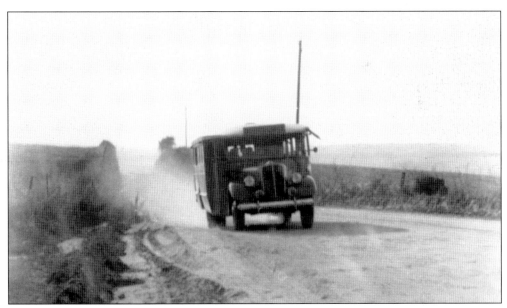

Before the new high school opened, students traveled to Oceanside for their high-school education, making the daily trip north by train. With the opening of the new school, however, students could travel by bus on the local unpaved roads, pictured here in 1938, to attend their daily classes. (Courtesy of the Scott family.)

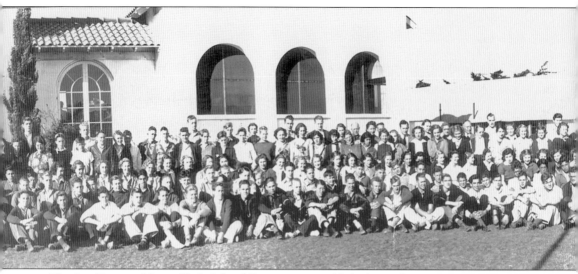

The San Dieguito Union High School District was established on February 3, 1936. By March, a school board was organized with Herschell Larrick as president. Before the new school opened, students attended classes in tents at the Primary School campus located directly in front of the site of the original 1883 Encinitas schoolhouse. Completed in 1916, it was built in the Spanish Mission style and at the time had a bell tower that was later removed in the 1930s for fear of

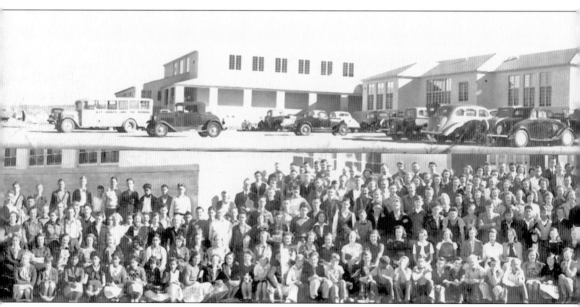

This combination photograph taken in 1938 shows the students and the completed campus of the San Dieguito Union High School. Disharmony between some staff members and the principal, Arthur Main, soon began to surface. By 1939, a list of complaints had been filed with the school

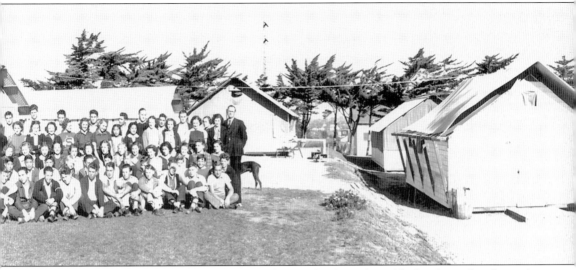

earthquake damage. The building functioned as a school until 1935 before being briefly used as a recreation center after the new high school opened. In 1953, the structure was moved to 939 Second Street and integrated into the Self Realization Fellowship Hermitage and Ashram buildings where it stands today. (Courtesy of Jimmy and Betty Brass.)

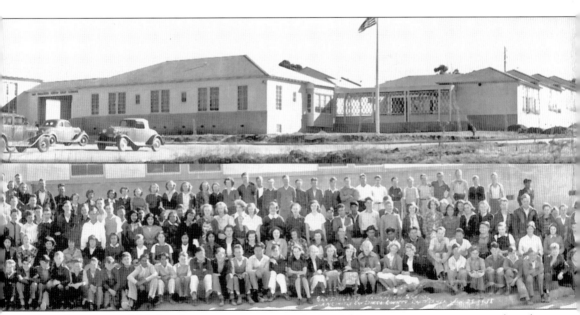

board criticizing Main's strict management style. In 1940, his contract was not renewed, and during the war, he was hired to teach at the Poston Japanese relocation camp. (Courtesy of Jimmy and Betty Brass.)

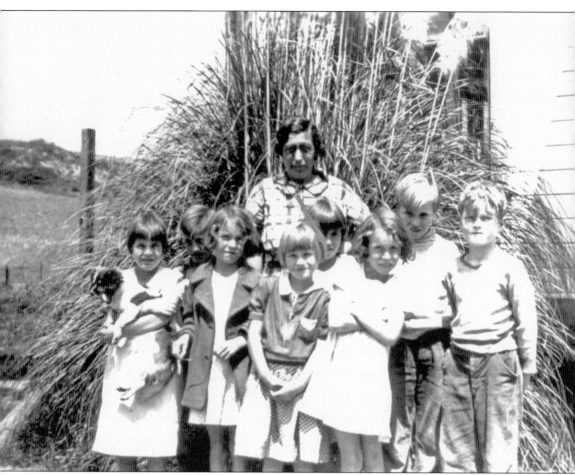

The Green Valley one-room schoolhouse, built in 1895, once stood along El Camino Real between Levante and Olivenhain Roads. Ada Harris is pictured here with her students next to the school building. Ada later taught in Cardiff, becoming teacher/principal of Cardiff Central Elementary School, originally known as Cullen School as it was named for early Cardiff developer Frank Cullen. Ada's name was immortalized in 1960 when, as superintendent of the school district, a second elementary school was built and named in her honor. (Courtesy of the Scott family.)

Two

THE ECKE FAMILY

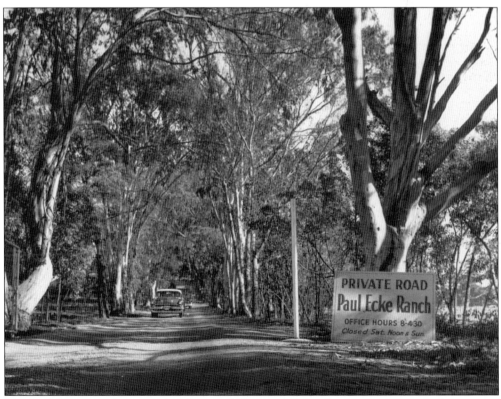

The Paul Ecke story begins with Albert and Henrietta Ecke, German immigrants whose strong family ties and work ethic would lead their descendants to ultimately be the largest supplier of poinsettias in the world. This 1940s photograph shows the entrance of the world-famous Paul Ecke Ranch on Saxony Road in Encinitas. (Courtesy of the Ecke family.)

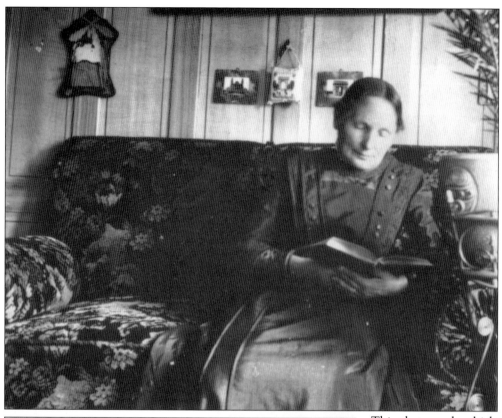

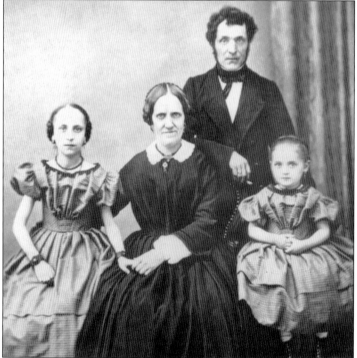

This photograph, which dates back to the 1800s, shows grandmother Roelli in her home in Switzerland. Her granddaughter Magdalena Maurer would marry Paul Ecke Sr. many years later on December 31, 1924. (Courtesy of the Ecke family.)

Taken in 1864, this group shot of the Moerhring family, taken in Magdeburg, Germany, shows Henrietta (at far right at about age five), who would late marry Albert Ecke. To her left are her father, mother, and stepsister. (Courtesy of the Ecke family.)

The Maurer family home in Switzerland is captured in this 1800s photograph. Magdalena, one of eight children born to Robert Maurer, a pious minister and strict disciplinarian, and Louise, immigrated to California with the family when she was two years old. (Courtesy of the Ecke family.)

Henrietta Ecke had this portrait taken in 1926. She was the faithful rock who stood by her husband, Albert, as he made the transition from being a teacher to owning a sanitorium in Germany. Unsettled with this venture, the family of six left Baden Baden to immigrate to the United States, arriving in California in November 1902. (Courtesy of the Ecke family.)

Magdalena is captured in this innocent portrait with her brother Ted, accompanied by a canine member of their family of 10. By the time this photograph was taken in 1907, the Maurer family had already left Switzerland and was living in Hollywood, California, after having initially settled in Montana. (Courtesy of the Ecke family.)

The four Ecke children are pictured in this 1900 portrait taken in Germany. From left to right, they are Margaret, Paul Sr., Frieda, and Hans. (Courtesy of the Ecke family.)

In 1899, this relaxed portrait shows Paul Sr. at age four and his older sister Frieda. Taken at the family's newly acquired health spa, or sanitorium, in Baden Baden, the natural life was promoted, and the children were free to dress scantily, or in Paul's case, sometimes without any clothing at all. (Courtesy of the Ecke family.)

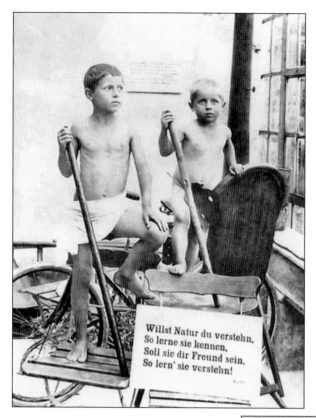

Hans and Paul pose for this 1901 photograph, which could have served as an advertisement for the Ecke's sanatorium. The translation of the German phrase is as follows: "If you understand Nature, get to know her. If she should be your friend, then you will understand her." (Courtesy of the Ecke family.)

Willst Natur du verstehn,
So lerne sie kennen.
Soll sie dir Freund sein,
So lern' sie verstehn!

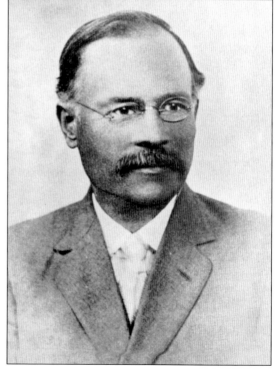

This portrait of Albert Ecke was taken in 1919. As a young man raising and supporting his family, his interest in health and vegetarianism almost led him to immigrate his family from Germany to Samoa. Fate dealt a hand, however, when a visitor to his sanatorium told him that he was making a big mistake and should look to California instead, which was just as rich with fresh fruit and vegetables. (Courtesy of the Ecke family.)

The Ecke family, on arrival in California in 1902, first lived in makeshift conditions in Hollywood, which had a population of less than 1,000 at the time. However it was not long before the family moved to their new six-room home on a 22.5-acre farm in Eagle Rock, just east of Los Angeles, pictured here in 1904. (Courtesy of the Ecke family.)

When this group portrait was taken in 1904, tragedy had already struck the Ecke family. Sadly when the children were playing with guns, Margaret was accidentally killed. This needless loss cast a dark shadow over the family, especially on Henrietta, who was not only grief-stricken but also carried a sense of guilt about the incident, which was never clearly explained. (Courtesy of the Ecke family.)

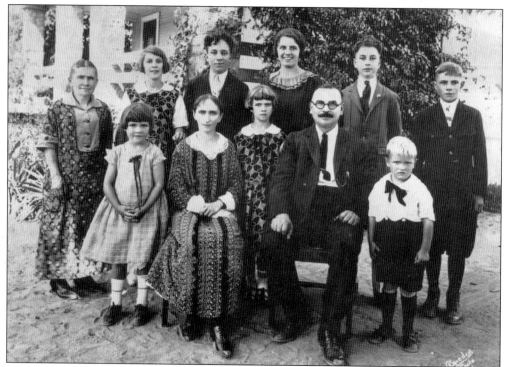

This 1923 group photograph shows the extent of Magdalena's family, the Maurers. As a young woman, she would help her neighbors, the Eckes, particularly at Christmastime when the poinsettias were in full bloom and many hands were required to meet the demands of seasonal sales. It would be another year before Paul would propose to Magdalena. (Courtesy of the Ecke family.)

With the tragedy of his brother Hans dying of influenza in 1918, followed by is father's passing in 1919, Paul Sr. shouldered the full responsibility of running the family's business. In 1922, he sold part of their dairy land for $8,000, which was used to purchase the Encinitas Ranch. By 1925, he had married his cherished 19-year-old Magdalena and moved part-time into the ranch house captured in this photograph that same year. (Courtesy of the Ecke family.)

This impromptu snapshot shows the fun nature of Paul Sr. and Magdalena's relationship. When Paul first proposed to Magdalena, they were both shocked that her parents did not approve of the marriage, citing the fact that she was only 19 and Paul Sr. was 10 years older. Undeterred they eloped on New Year's Eve in 1924. (Courtesy of the Ecke family.)

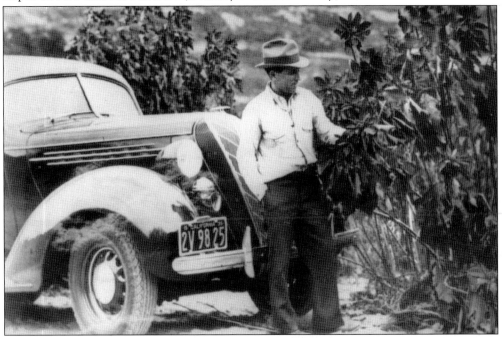

The land for growing poinsettias has to be frost free and located conveniently close to a railroad to facilitate shipping. Initially Paul Sr. considered buying land in Carlsbad, but at $600 an acre, it was priced too high. When property was found near the small village of Encinitas at $150 an acre, Paul seized the opportunity to purchase it. This photograph, taken 10 years after the sale, shows Paul Sr. overseeing the abundant crop of poinsettias that thrived in the moderate coastal climate. (Courtesy of the Ecke family.)

Over the decades of their marriage, Magdalena proved to be the perfect partner for Paul Sr. He admired her intelligence, her qualities as a mother and wife, and her sense of humor, as illustrated in this 1925 portrait. She raised their three children with a firm but gentle hand and was the essential counterpart to Paul Sr. (Courtesy of the Ecke family.)

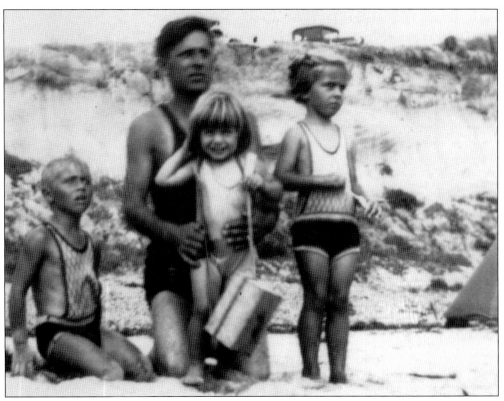

Paul Ecke Jr. was born on December 14, 1925. Soon Barbara and Ruth, known as Crix, would follow. This 1931 photograph, taken at Moonlight Beach, shows Paul Sr. enjoying the company of his three children. (Courtesy of the Ecke family.)

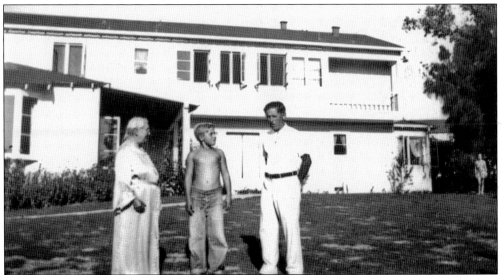

Paul Sr. is pictured with Paul Jr. and grandmother Henrietta Ecke. This 1937 photograph was taken in front of the newly built ranch house, designed by local architect Lilian J. Rice, who had designed the buildings for Rancho Santa Fe a decade earlier. The home was completed in 1936. (Courtesy of the Ecke family.)

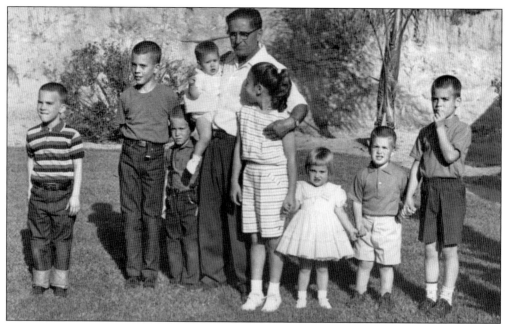

There is no question that Paul Sr. was a family man. This photograph, taken at the Ecke Ranch in 1960, comprises the patriarch with his eight grandchildren. Pictured, from left to right, are Duane Winter, Ray R. (Bob) Winter, Paul Ecke III, Sara Ecke, Paul Sr. (Papa Paul), Christine Dealy, Lizbeth (Buffie) Ecke, Matthew (Matt) Dealy, and Charles W. (Chuck) Dealy III. (Courtesy of the Ecke family.)

The current generation of the Ecke family is headed up by Paul Ecke III, pictured with sisters Lizbeth Ecke to his left and Sara Ecke May to his right. The Eckes continue to be a major presence in the floriculture industry, both in the seedling business and in the breeding and export of the poinsettia. The family continues to give generously to philanthropic causes, donating land and funds to local organizations like the YMCA, and is a provider of employment for many residents. (Courtesy of the Ecke family.)

Three

OLIVENHAIN

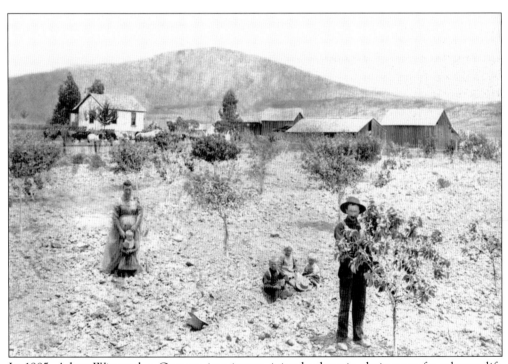

In 1885, Adam Wiegand, a German immigrant, joined others in their quest for a better life when he joined the Colony Olivenhain. The resulting disappointment when settlers discovered that their land deeds proved worthless and the lack of fresh running water led Adam, his wife, Christiana, and their children, pictured here in 1893, to abandon the colony. (Courtesy of the Scott family.)

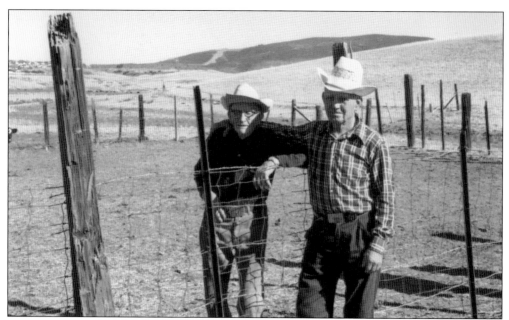

Herman Wiegand was one of Adam and Christiana's five children. He was born at the family homestead ranch on Aliso Canyon Road on April 15, 1890. Herman's permanent home became the new Wiegand Ranch on Manchester Road. A true cowboy, Herman, pictured here at left in 1980 with neighbor and friend Art Cole, was still riding his favorite horse, Tecla, well into his 90s. (Courtesy of Lynwood Cole.)

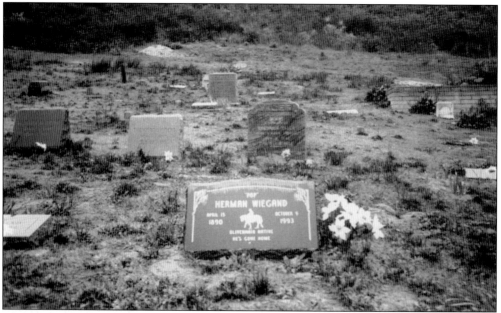

The first burial in the Olivenhain cemetery was of Emile Hauck, who passed in 1891. Located on property near the Colony Terrace in Olivenhain, the 1.9-acre cemetery is used exclusively for original settlers and their descendants. The headstone in the foreground belongs to Herman Wiegand. Engraved with his dates, 1890–1993, he was age 103 at his passing. (Courtesy of Ken Holtzclaw.)

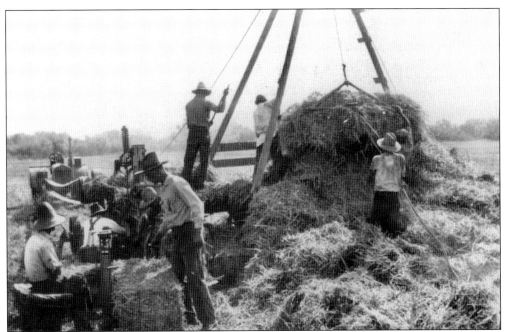

Olivenhain was synonymous with farming for almost 70 years. This photograph, taken around 1929, shows the "Roughneck Squad," with Herman Bumann, second from the left, supervising the baling of hay. By then, tractors had replaced the use of horsepower, but manpower was still required to physically maneuver the Jackson Fork, which hauled the hay up into the derrick wagon. (Courtesy of Lynwood Cole.)

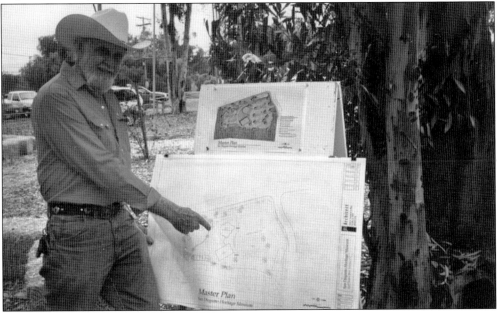

Dave Young points out the plans of the proposed new location for the San Dieguito Heritage Museum of which he is a member. It will be housed in a complex of buildings that include the former 1892 Teton home, an adjoining 1917 Granny shack, and a migrant worker's bunkhouse. (Courtesy of Ken Holtzclaw.)

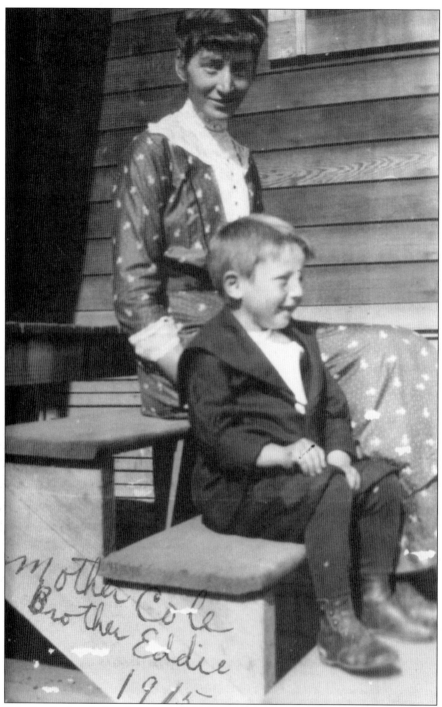

The Cole family, headed up by patriarch Silas Cole, settled in Olivenhain in the mid-1890s. Clarence, their first child, born in Nebraska in 1884, married Amanda Clara Koehn in 1904 when he was age 20. Pictured here in 1915 is Amanda with one of their three sons, Eddie. For the first few years of their marriage, until Clarence built a home for them on Lone Jack Road, they lived on Silas Cole's ranch. (Courtesy of Lynwood Cole.)

The eldest of the three Cole boys, Art remained in Olivenhain to follow a lifelong career in farming. This 1978 photograph was taken on the threshold of the Olivenhain Town Hall when Art was 72 years old. He was being honored for his contributions to the community of Olivenhain during a day of celebration in July that became known as Art Cole Day. (Courtesy of Lynwood Cole.)

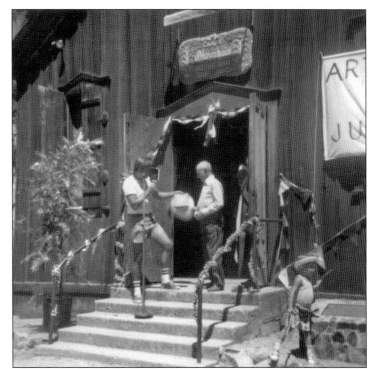

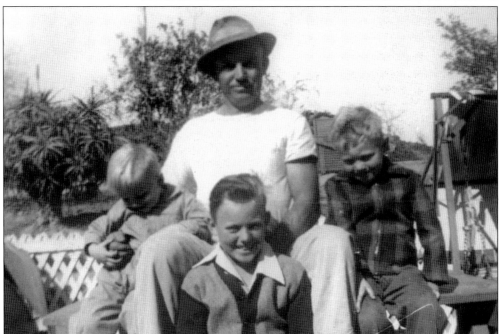

Art Cole, the proud father of three boys—Lynwood, Stanley, and Art Jr.—poses in this family photograph taken at the Cole Ranch, c. 1945. From the mid-1920s to the mid-1960s, Art not only farmed but was known as the local tractor man. He was constantly working on them and would have up to 15 at any one time dotted around the ranch. If neighbors' vehicles got stuck in the mud, Art would turn out at any hour to rescue them. (Courtesy of Lynwood Cole.)

Considered a basic accommodation for many pioneer settlers in Colony Olivenhain, this one-window, one-room shanty is now on permanent display at the site of the meeting hall. This was no-frills housing at its best, constructed to either a 12- by 14-foot or a 14- by 16-foot dimension. Shanties were very popular with the original colonists and totaled about 80 percent of all dwellings constructed. (Courtesy of Ken Holtzclaw.)

The Olivenhain Meeting Hall was built in 1894, 10 years after the arrival of the first colonists. The structure was constructed on the south side of block No. 36 using lumber that was shipped in to Encinitas. Aided by volunteers, Bill Dommes was hired for $6 an hour to build the hall. Inside a musician's stage was erected, making the hall the hub for social gatherings. (Courtesy of Ken Holtzclaw.)

The largest home built by the colonists was that of Herman Baecht. Constructed in 1885 for $500, Baecht anticipated using the home as a hotel and even named it the Germania Hotel. But the home also remained a comfortable dwelling for Baecht's family of 12. The building's steeple was restored when the home was relocated to its current site next to the Olivenhain Meeting Hall. (Courtesy of Ken Holtzclaw.)

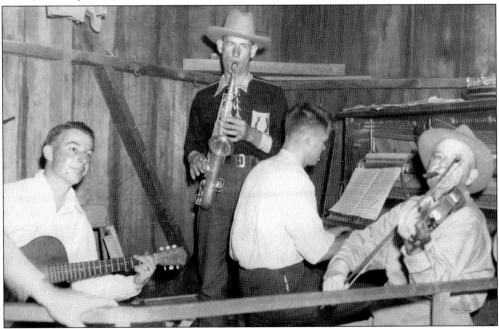

Taken in 1945, this wartime photograph shows the Harvey Band during a popular Saturday night dance. Pictured, from left to right, are Eddie Cole, Herman Bumann, Mac Brink, and Fred Harvey. The Owl Club organized many social events at the meeting hall. In 1928, they installed a new dance floor and made much-needed repairs using funds raised by selling wood logs from downed trees that had dominated the hall site. (Courtesy of Lynwood Cole.)

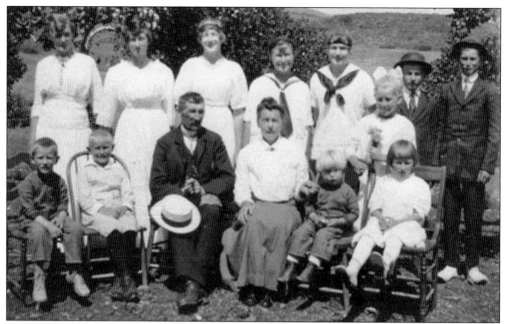

Members of the Bumann family, German immigrants who initially settled in Colorado, had arrived in Olivenhain by 1884. This photograph shows Herman F. Bumann, the second son of Frederick August Johann Bumann, with his wife, Emma Marie Junker, whom he had married in December 1893. They had 12 children—seven girls and five boys. (Courtesy of Roger and Jeanette Teten.)

When Herman F. Bumann passed away in 1926, his son, Herman C. Bumann, was the only family member who remained to work the ranch. The family lived on a 160-acre homestead purchased for $50, which covered the cost of land and improvements, from Conrad Stroebel in 1886. This 1939 photograph shows Herman playing the fiddle with friend Bing Crosby at far right. (Courtesy of the Scott family.)

Although the Bumann girls helped with some of their father's ranch work, it was not all work and no play. Five of the Bumann girls pictured here provide a snapshot of their leisure activities. Note the big-wheeled touring buggy that was often used for pleasure trips around the countryside. (Courtesy of Roger and Jeanette Teten.)

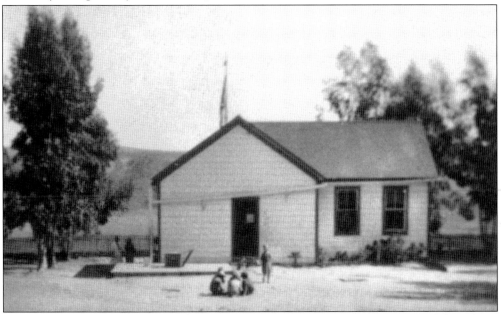

Olivenhain did not have a school during the first 21 months of the formation of the colony. When Theodore Pinther was run out of the area after swindling the colonists, his vacant home became a temporary school. By 1888, however, the colonists had purchased Fred Balzer's home, moved it to the southwest corner of Seventh and E Streets, and made it the permanent school seen in this 1918 photograph. It would serve Olivenhain's children for 54 years. (Courtesy of Lynwood Cole.)

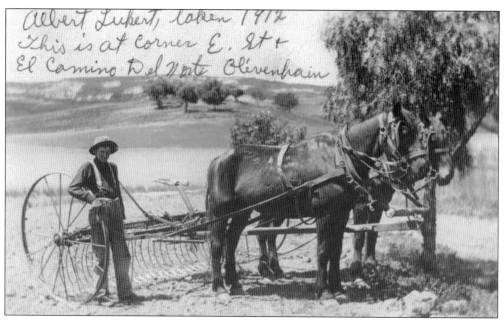

This 1910 photograph shows Albert Lickert with a rare glimpse of an olive grove in the background. Despite the fact that Colony Olivenhain was marketed as a verdant land suitable for growing olives, the truth was quite the opposite. The lack of fresh running water resulted in most farmers raising livestock or dry farming lima beans and grain. (Courtesy of Lynwood Cole.)

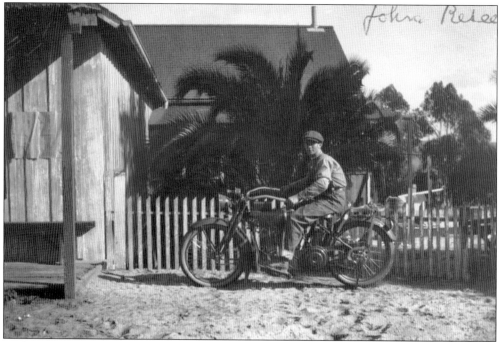

With the improvements in motorized vehicles, the motorbike soon became the preferred mode of transportation for many colonists. This undated period photograph shows motorcyclist enthusiast John Reseck, the son of Bernard and Anna Reseck, who homesteaded the 160 acres later known as Lone Jack Ranch. (Courtesy of Lynwood Cole.)

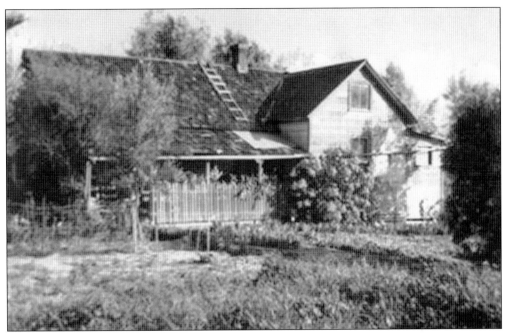

The house in Olivenhain that is pictured here is the birthplace of John and Laura Teten's son Roger, one of three surviving children. The house served the Teten family well during their farming years in Olivenhain, and today it has been transported to a site just north of Quail Botanical Gardens on property donated by the Paul Ecke family. (Courtesy of Roger and Jeanette Teten.)

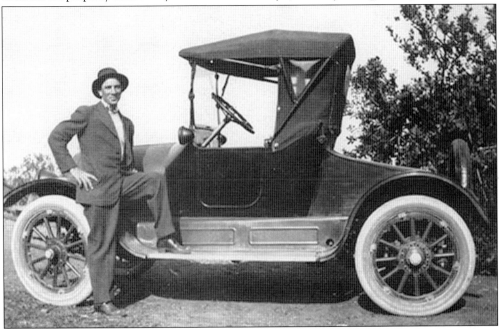

By the mid-1920s, John Teten was farming on an approximately 100-acre ranch with hundreds of turkeys, New Hampshire red laying hens, and a moderate head of cattle. He also dry-farmed lima beans, hay, and grain. The family prospered, affording the purchase of this early-model Overland touring coupe. (Courtesy of Roger and Jeanette Teten.)

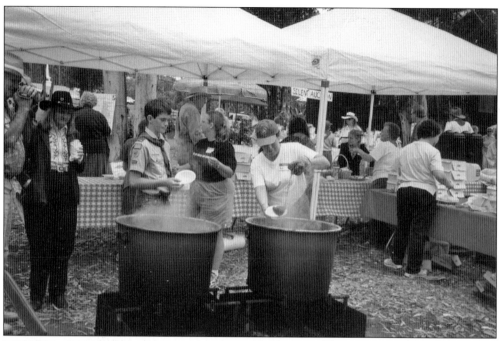

This is a scene from the 2004 barbecue that the San Dieguito Heritage Museum launched as a fund-raiser for development of their new museum site. The two large pots that the beans are being cooked in are reminiscent of the way the Olivenhain pioneers used to cook lima beans when they had barbecues such as this one. (Courtesy of Ken Holtzclaw.)

This 1954 shot shows John Teten who migrated to Olivenhain in 1892 with his German family when he was five years old. They settled in Olivenhain at 211 Rancho Santa Fe Road, which became the family's permanent home. John was only 13 years old when his father died, leaving him to run the ranch. In 1944, he became a member of the National Turkey Federation of Mount Morris, Illinois. (Courtesy of Roger and Jeanette Teten.)

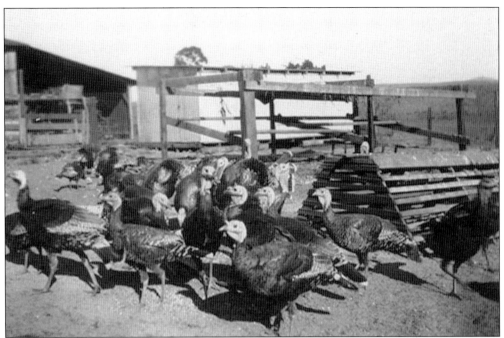

This group of turkeys is a small sampling of the more than 3,000 raised on the Teten farm. Raising turkeys was extremely hard work, and they were difficult to manage. Female turkeys wore "turkey saddles," a protective canvas vest used to keep Tom turkeys at bay. The Teten children had to herd the turkeys into their pens at night, which was particularly challenging if they flew into the nearby trees. (Courtesy of Roger and Jeanette Teten.)

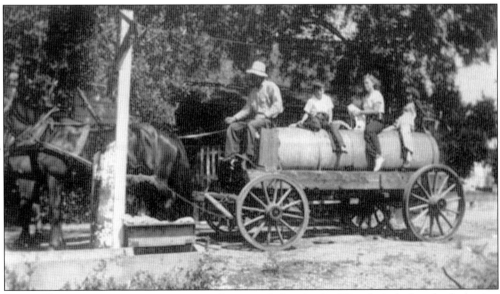

Pictured here is a water wagon, a necessity during early farming in Olivenhain before the formation of the Olivenhain Municipal Water District in 1961 when piped water came to the region. Jonn Teten is driving, with his son Roger behind him and friend Betty Jean Hughes and sister Gladys riding behind him. (Courtesy of Roger and Jeanette Teten.)

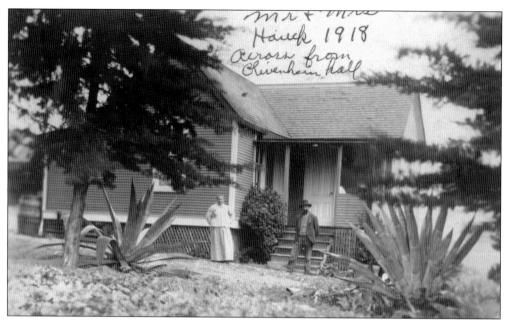

This 1918 photograph shows the Haucks in front of their home, located across from Olivenhain Hall. Herman Hauck planted a four-and-a-half-acre apple orchard on the northwest corner of Rancho Santa Fe Road and Eighth Street around 1913. He also had a vineyard that produced fine-quality wines. (Courtesy of Lynwood Cole.)

Survival for the colonists meant that children played a huge role in the daily running of the ranches. This 1913 photograph shows a 12-year-old Art Cole, grandson of Silas Cole, driving an overloaded hay wagon. (Courtesy of Lynwood Cole.)

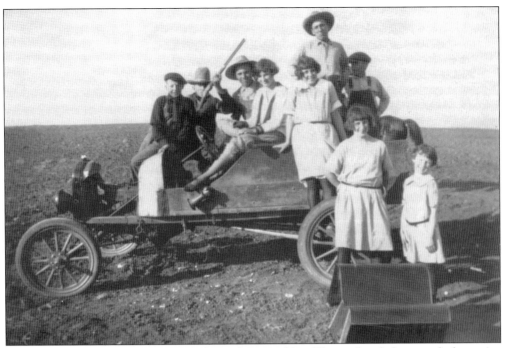

Hard work on the farm did not preclude an absence of fun. This undated photograph shows Art Cole at the steering wheel of his stripped-down Model T Ford, with his "dear friends" joining in. (Courtesy of Lynwood Cole.)

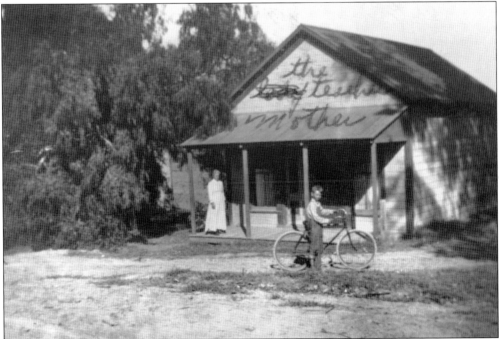

According to handwritten notes on this photograph, Art Cole, with his bicycle, and Mrs. Colburn, the local teacher, have been photographed either in 1908 or 1910 in front of the Hess store, formerly Nobel's store. (Courtesy of Lynwood Cole.)

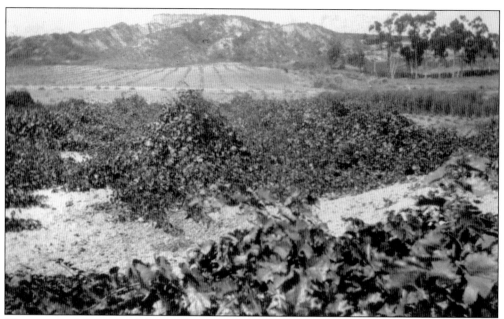

This vineyard was one of the Denk family's many farming ventures. Taken around 1920, The photograph shows one of the many products grown on their vast ranch. The Denks were the most successful lima bean–growing farm in the area, threshing annually as much as 1,900 acres. (Courtesy of the Denk family.)

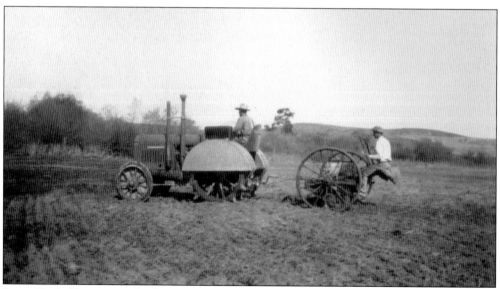

Bruno Denk, like many in the farming community, welcomed mechanization. This 1930 photograph shows Bruno in his state-of-the-art 1927 10-20 McCormick Deering tractor. Ed Cole is seated behind on the seed drill. (Courtesy of the Denk family.)

Four

CARDIFF-BY-THE-SEA

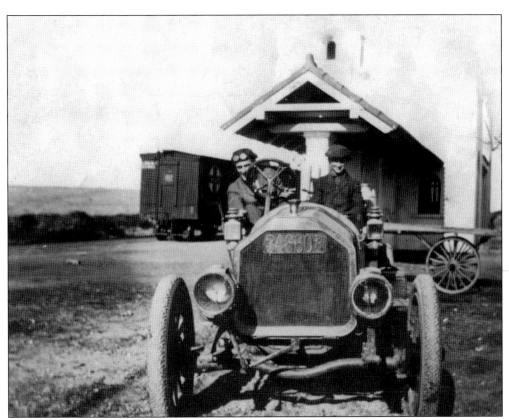

Warner Rathyen, a mechanic and owner of the Encinitas Garage, and, surprisingly, the first librarian in Encinitas, is pictured here with Douglas Satterlee in this 1913 photograph taken in front of the Cardiff train depot. Each day, they delivered milk to the depot in this early right-handed Buick Roadster. (Courtesy of Lynwood Cole.)

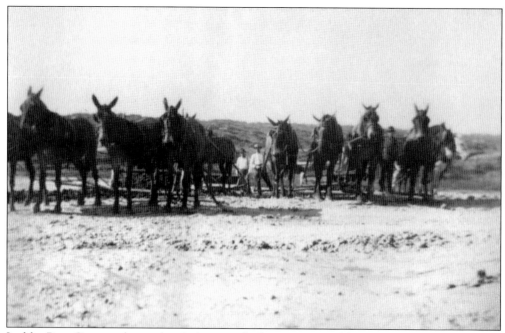

Led by Bert Cozens, this undated photograph shows a team of horses grading the dirt roads in Cardiff. Hector Mackinnon, a Scottish immigrant, was the first settler in this small coastal enclave, homesteading 600 acres in 1875 on the north side of the San Elijo Lagoon, two miles south of Encinitas. (Courtesy of the Scott family.)

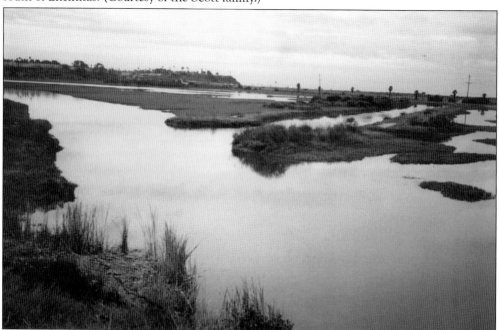

This westward shot captures the San Elijo Lagoon, which forms the southern border of Encinitas. It was named in honor of Saint Alexius, whose feast day occurred when the Portola expedition camped at its edge on July 16, 1769. The lagoon, one of the area's largest coastal wetlands, encompasses approximately 1,000 acres of diverse habitat. (Courtesy of Ken Holtzclaw.)

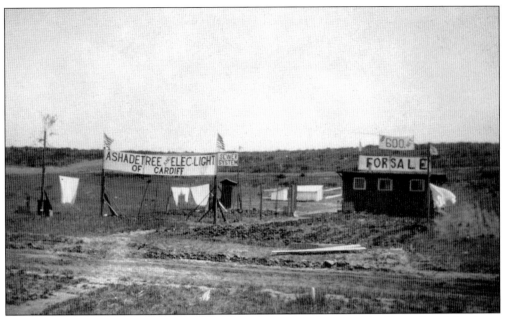

Notable in this early undated photograph of Cardiff is the absence of buildings. Land developer Frank Cullen purchased some of Mackinnon's land in 1911, named the township after his wife's suggestion, and named the streets for British cities. By 1915, there was further development that included a restaurant, a train depot, and a hotel now known as the Cardiff Mercantile Building. (Courtesy of the Scott family.)

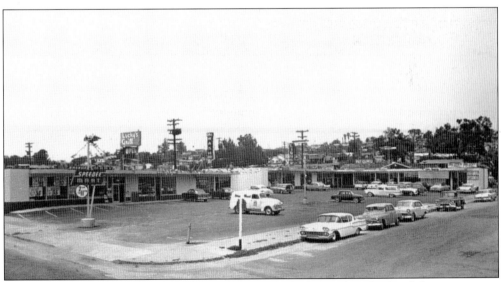

Cardiff-by-the-Sea soon began to prosper, and during the late 1950s, this local shopping center on Aberdeen Street was thriving. By 1969, V. G. Donut and Bakery, a Cardiff landmark owned by the Metee family, had opened there and become a tradition. It is referred to locally as the Cardiff City Hall, where "decisions are made." (Courtesy of Dave and Bertha Young.)

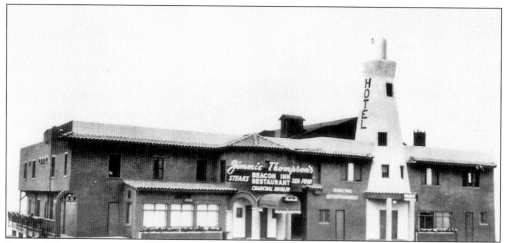

Jimmie Thompson's Beacon Inn was located along the beachfront on Coastal Highway 101. Originally built in 1928, it became a favorite local attraction, entertaining celebrities like Betty Grable, Harry James, and Jimmy Durante. Its illuminated lighthouse created a local landmark until it closed in 1962 after its final New Year's Eve party. (Courtesy of the San Dieguito Heritage Museum.)

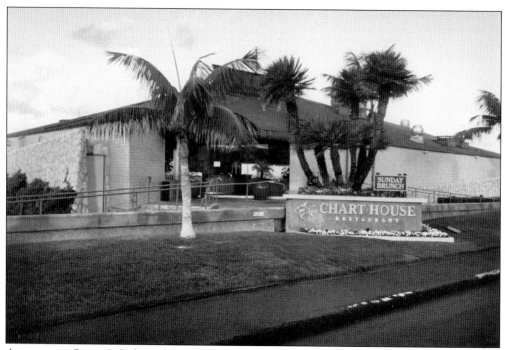

At one time, George's Café was located on the same real estate where the Chart House now stands. Owner George Beech began building his inn in 1916, using lumber that came from the Cardiff Kelp Works. George's Café became a favorite with celebrities like Bing Crosby and Pat O'Brien during the 1940s and 1950s. The restaurant remained in the family for decades until grandson Bobby San Clemente sold it to the Chart House. (Courtesy of Ken Holtzclaw.)

Part of restaurant row in Cardiff is Michael Crawford's Charlies by the Sea, which replaced the Hydra Restaurant when it burned down. With neighboring restaurants the Beach House and the Chart House, their locations were once the sites of the Beacon Inn and George's Restaurant. (Courtesy of Ken Holtzclaw.)

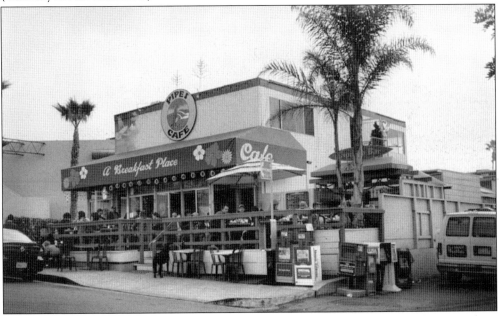

Named for the nearby surf spot, this beach-shack eatery is "long on flavor and funky atmosphere and short on fuss," according to its website. Pipes Café, located at 121 Liverpool Drive, is a local favorite famed for great food, low prices, and its surf-culture decor. A mural serves as a road map to North County surfing, from Stone Steps in Encinitas to the Pillbox in Solana Beach. (Courtesy of Ken Holtzclaw.)

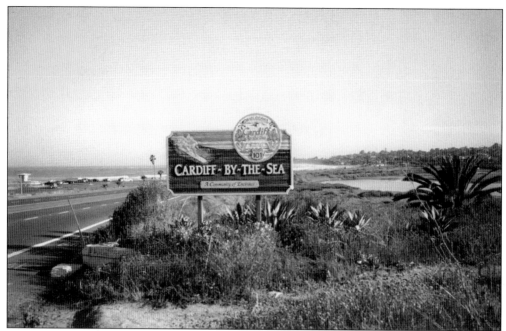

The sign that welcomes visitors into the most-southern beach community of Encinitas highlights the surfing culture. Cardiff-by-the-Sea is home to famed pro surfer Rob Machado. Each year, 40,000 spectators descended on Cardiff Reef and Cardiff State Beach for the Hansen and Machado Surf Classic and Cardiff Beach Fair. However the 2006 event was cancelled due to a huge increase in fees by the county. (Courtesy of Ken Holtzclaw.)

One of the most pleasant beach campsites along San Diego's north county coast is the San Elijo State Beach Campground. With spectacular views, it is located on the bluffs at the shore of Cardiff-by-the-Sea and is in such high demand that reservations need to be made at least 12 months ahead of time. (Courtesy of Ken Holtzclaw.)

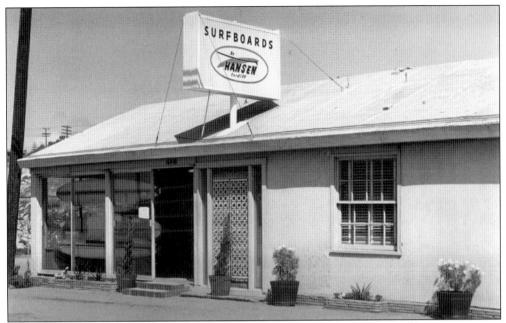

Hansen's started in a little shack on Kawela Bay, North Shore, Oahu, in 1961. Surfer/shaper Don Hansen, who redefined surfboard design, moved to Cardiff-by-the-Sea in the spring of 1962 where he opened up his first California-based Hansen Surfboard shop on the beach at the Cardiff reef. Eventually Hansen Surfboards became one of the most recognized names in surfing, giving Don Hansen celebrity status. (Courtesy of Don Hansen.)

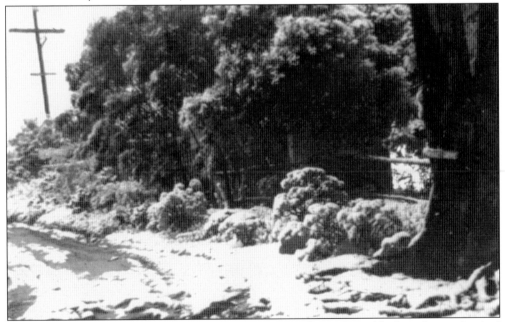

Local residents awoke to a surprise one morning in December 1967—a blanket of snow that had fallen during the night. While this may not seem earth-shattering, before this date snow had not fallen since 1865 and has not been witnessed in the area since. This photograph of Crest Drive, taken by Dave Young, captured the rare phenomenon. (Courtesy of Dave and Bertha Young.)

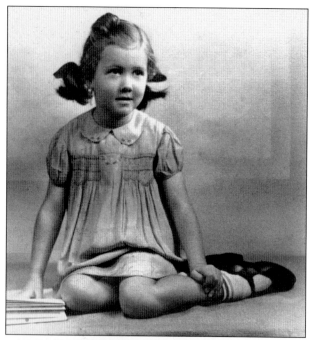

Wendy Haskett was a much-loved English immigrant who settled in Cardiff with her husband in 1961. She is about four years old in this photograph, taken in the Manchester area where she was raised. Originally a hairdresser, for the last eight years of her life Wendy wrote a lively newspaper column, "Backward Glances." Wendy passed away in 2006 from cancer. Her husband, Scotty, and two sons, Gordon and Craig, still live in the area. (Courtesy of the Haskett family.)

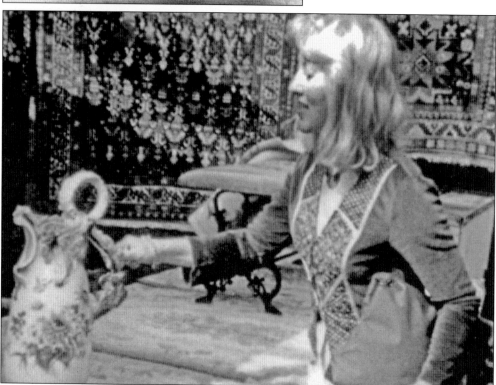

This photograph of Wendy Haskett, taken by her mother, Cordelia Rimington, at the Leucadia Flea Market in the 1970s, appeared on the back of one of Wendy's books, *Backward Glances.* Compilations of her weekly newspaper columns, the books featured hilarious life stories from San Dieguito residents. (Courtesy of the Haskett family.)

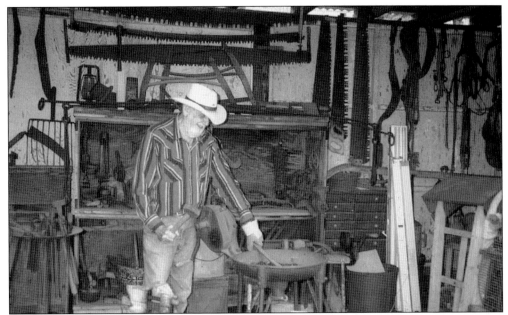

Dave and Bertha Young's home in Cardiff has historic ties to the early settler Walter Mackinnon, brother of Cardiff settler Hector Mackinnon. The Youngs showed the authors a copy of the original deed to the property, which includes remnants of Mackinnon's first Cardiff home. Dave has converted part of the outside buildings into this recreation of a blacksmith workshop. (Courtesy of Ken Holtzclaw.)

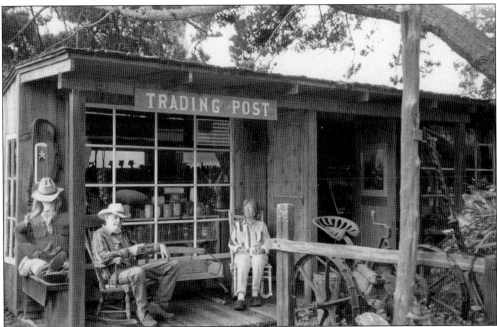

Avid collectors of historic artifacts, Dave and Bertha Young have converted their home on Crest Drive into a living museum. The Trading Post, located behind the main house, represents many decades of accumulated antiques that make up the Young's vast collection. (Courtesy of Ken Holtzclaw.)

Cardiff resident Dan Dalager was captured in this *c.* 1951 photograph when he was barely a year old. Having grown up in the still-developing coastal community in a home behind the Cardiff Towne Center, Dan and his brother Myron now own and operate the family business, Dalager's Sharpening Service on Second Street in downtown Encinitas. (Courtesy of Dan Dalager.)

This 1961 class photograph, taken at Cardiff Elementary, shows George Berkich with his sixth-grade class. Berkich would later become the school's principal, and a Cardiff baseball park would be named in his honor. One of Wendy Haskett's clients when she was in the hairdressing business was George Berkich's wife. (Courtesy of Dan Dalager.)

Dan Dalager, pictured here as a kindergartner, became mayor of Encinitas in 2004. He was elected to city council when residents urged him to run for office following their frustration with an awaited approval for a proposed toddler's park. After 11 years of waiting, the permits were approved while Dan was on the council. The tot lot was subsequently constructed. (Courtesy of Dan Dalager.)

This 1946 photograph shows Cardiff resident Valero Dalager starting married life by pumping up a flat tire. Apparently a joke, however, this was not a portent for things to come. Hans and Valero Dalager, both marines in active service during World War II, were married at Cardiff Methodist Church on October 5, 1946. (Courtesy of Dan Dalager.)

In 1985, a group of residents on Birmingham Street in Cardiff-by-the-Sea wanted to have a sidewalk put along their street but were unsuccessful in obtaining city funding. In a show of community spirit they obtained and paid for their sidewalk by selling small segments of the proposed project for $15 each. Donors inscribed their family names on each slab. (Courtesy of Ken Holtzclaw.)

Five

LEUCADIA

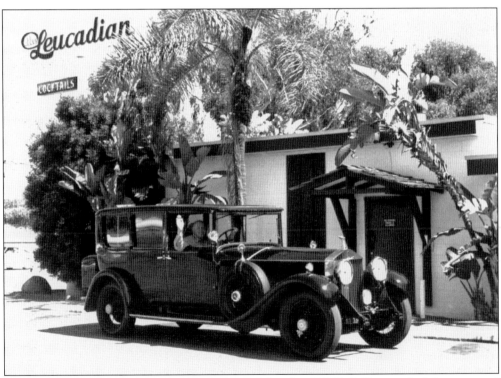

Andy Kentera displays his version of a "royal wave" from his 1931 Rolls Royce, which he co-owned with his brother John Kentera. Together they ran Bar Leucadian, which opened in 1954. The bar is still in operation and is located at 1542 North Coast Highway 101 in Leucadia. (Courtesy of John Kentera.)

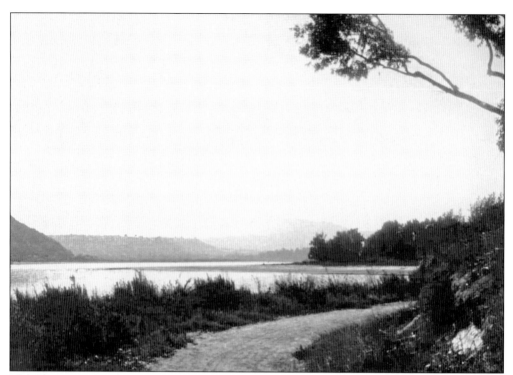

The Batiquitos Lagoon was home to some of the areas first inhabitants, the Kumeyaay. In 1875, Nathan Eaton, a bee farmer who homesteaded on the south side of the lagoon, named the area Eatonville. It would later be called Leucadia ("sheltered paradise" in Greek) by an English group of spiritualist settlers who named the area streets after Greek gods. (Courtesy of Cole Library.)

This early view of North Coast Highway 101 shows the absence of buildings and the number of eucalyptus trees originally planted by English settlers. Attempts by pioneer E. B. Scott to rename Leucadia Merle after his youngest son did not endure, and the name passed into history. Some believe that Leucadia's origins predate the formation of the Encinitas township. (Courtesy of Kristi Hawthorne.)

Leucadia Roadside Park is an open space retreat located at the beginning of Leucadia Avenue. Folklore has the spiritualists dancing in white flowing robes in this park. Today Leucadia is proud to be an eclectic mix of floriculture, small businesses, surfing enthusiasts, and artists. Car bumper stickers urge residents to "Keep Leucadia Funky." (Courtesy of Ken Holtzclaw.)

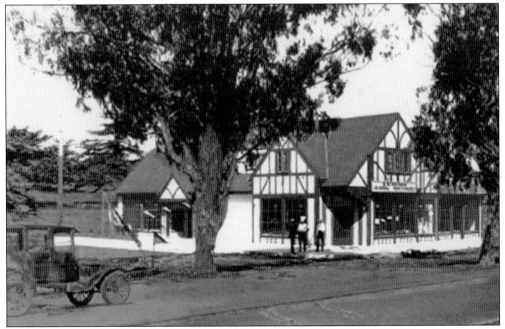

Once located next to Leucadia Roadside Park, this Tudor-style building burned to the ground in 1953. It belonged to famed naïve artist Streeter Blair, who used it as his studio and antique shop. In the 1960s, Sotheby's auction found a container with over 100 of his paintings, which were bought by collectors like Vincent Price and Jonathan Winters. (Courtesy of Fred Caldwell.)

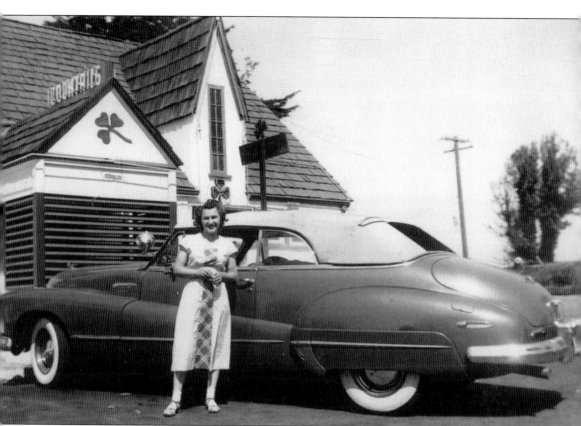

The Vienna family opened a restaurant called the Vienna Villa after closing their Leucadia eatery, the Blue Goose Café. Located where Cap'n Kenos stands today, the Vienna Villa restaurant later became Kolb's Drive-In, which was owned and operated by Aubry Austin who developed the La Paloma Theater complex and the bathhouse at Moonlight Beach. The drive-in then metamorphosed into the Shamrock Café, owned by "Mac" McCowen. This photograph shows customer Doc Perdue's wife and his 1948 Buick in front of the café. Located at 158 North Coast Highway 101, during the 1940s it was a favorite spot for celebrities to take a break en route between Mexico and Hollywood. (Courtesy of Gerry Sova.)

This illustration shows the El Rancho restaurant, which opened shortly after the Vienna Villa closed; another incarnation of the Shamrock Café. One of the restaurant's claims to fame occurred when Cardiff's Dave Young watched actor John Wayne break up a fight in its parking lot. Wayne held the two brawling men apart, walked them inside, and bought drinks for "the house." (Courtesy of Gerry Sova.)

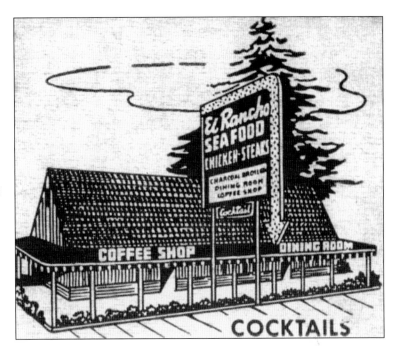

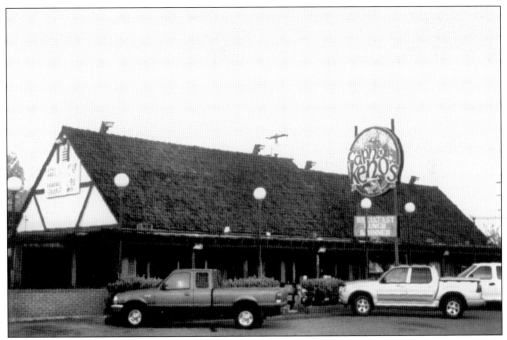

In 1970, El Rancho was purchased by Gerry Sova, who renamed it Cap'n Kenos. Initially Gerry ran the bar and restaurant as well as cooked and served tables. Today, 36 years later, the restaurant is a local treasure, renowned for the 400 Thanksgiving and Christmas dinners that Gerry serves annually for $3, or if cash is tight there's no charge—no questions asked. John Kentera donates the turkeys and V. G. Donut and Bakery of Cardiff donates the desserts. (Courtesy of Ken Holtzclaw.)

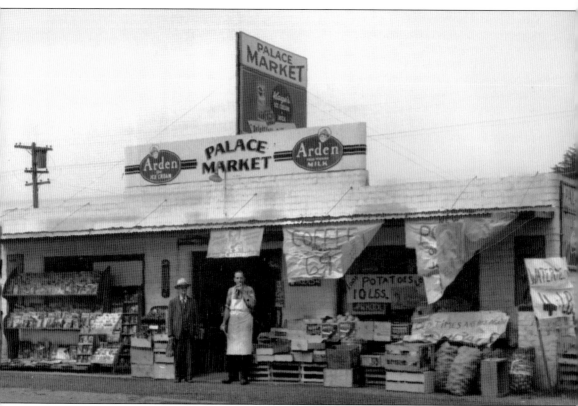

The Palace Market opened in Leucadia in 1946 and was named after the Palace Store in Madera, Arizona, where the owners, the Kentera family, originated. John Kentera stands at the front of the store next to customer John Davies, a retired violinist with the New York Symphony. In the 1950s, the store was demolished and became the parking lot for Bar Leucadian. (Courtesy of John Kentera.)

This classic photograph of John Kentera when he was 21 was taken following his 1949 boxing victory—the title of Nevada's State Heavyweight Boxing Championship. John lived and worked in Reno but relocated permanently to Leucadia in the early 1950s when he and his brother Andy opened up their restaurant and lounge, Bar Leucadian. (Courtesy of John Kentera.)

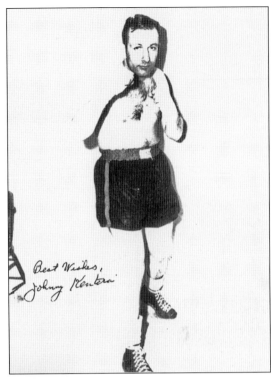

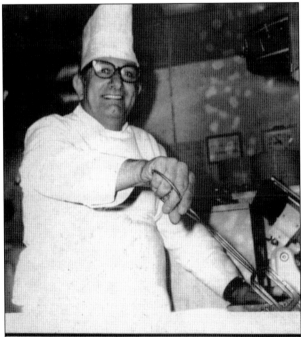

"BIG JOHN" KENTERA PREPARES to serve one of his prime steak dinners. If not in the mood for steak, try the ham, chicken, or seafood dinners at John's Leucadian. Located on old 101 Highway in north Leucadia, it is a true family restaurant, serving both luncheon and dinner, along with that favorite drink. Can't think of a better place in Leucadia to meet old friends, business associates or the family for dinner and a cocktail or two. *Dec. 1973*

This photograph of chef John Kentera, taken in 1973, captures a man with a big heart. For many years, he has donated turkeys for Cap'n Kenos's $3 holiday dinners. He also provides beef and chickens for community meals at the American Legion, which he barbecues on huge, custom-made spits, his unique invention. (Courtesy of John Kentera.)

83

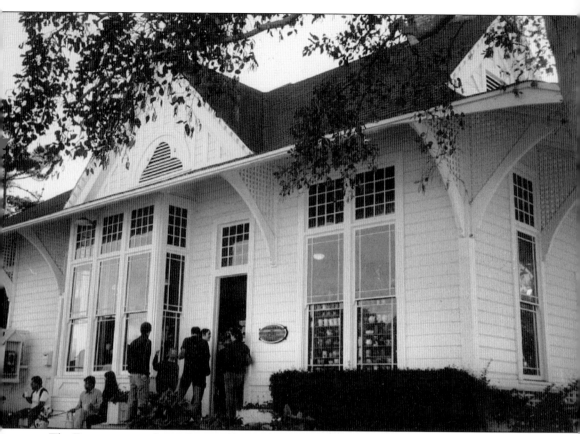

The Encinitas train depot, designed by Fred F. Perris and built in 1887, was a copy of the Carlsbad Station constructed the previous year. In the early 1900s, the Atchinson, Topeka and Santa Fe Railroad Company purchased the line from the Southern Railroad Company and repainted the depot in shades of mustard and red, their company colors. In the mid-1930s, as the automobile gained popularity, the station became a flag stop and by 1968 had permanently closed. Cardiff resident Jim Bowen purchased the depot building in the early 1970s and had it moved north to 510 North Coast Highway 101 where it served as an arts and crafts store. Bob and Jay Sinclair then purchased the building and had it converted into the Pannikin coffee shop in 1980. Now painted in cheerful lemon tones, this local landmark continues to be a favorite meeting place for residents and tourists. (Courtesy of Ken Holtzclaw.)

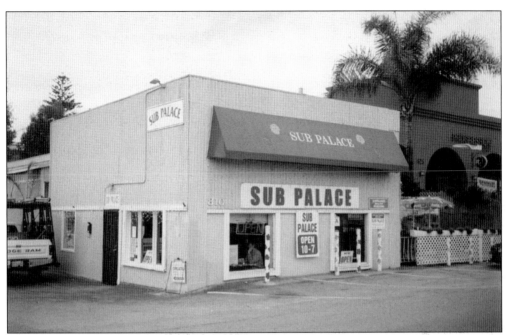

Once known as the Blue Goose Café, this North Coast Highway 101 eatery has been serving food to travelers since the early 1920s. For the last two decades, it has specialized in sub sandwiches as Steve's Sub Palace. An original sign from the store's front was recycled as a structural attic beam when the building was remodeled. (Courtesy of Ken Holtzclaw.)

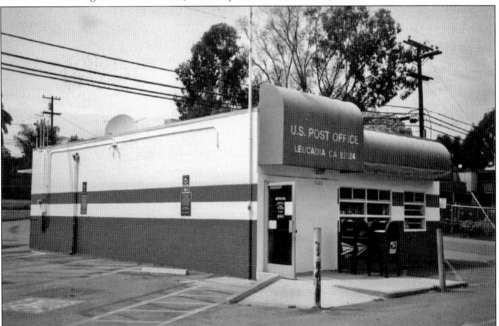

Along Leucadia's North Coast Highway 101 is this building that houses the U.S. Post Office. Wrapped in red, white, and blue, the structure has maintained its classic early identity and has become a community landmark, adding to the charm of historic Leucadia. (Courtesy of Ken Holtzclaw.)

Bob Weidner asked his wife, Evelyn, "How would you like a nice big patch of Tuberous Begonias?" Little did she know that he considered a big patch of about 25,000. Not only did Evelyn believe this to be overly ambitious—after all, they were supposed to be retired following the sale of their Buena Park Greenhouse business in 1969—but Bob expected the customers to dig up the begonias themselves. "Absolutely insane!" was Evelyn's reaction. However on July 5, 1973, the day "Dig Your Own Begonias" launched, it was clear that the concept not only worked but was fun. Pictured here is Evelyn with her daughter Mary at their greenhouse site on Normandy Street in Leucadia. Today customers may still dig their own begonias or purchase many varieties of plants, including impatiens, pansies, cyclamens, and poinsettias during the Christmas season. (Courtesy of Evelyn Weidner.)

A remnant of auto court days, this little roadside village of red cabins was built in 1935. Famous guests have included Sammy Davis Jr. and Sr., both of whom were regulars in cabin No. 5 in the 1960s when Leonard and Jeannie Fuller took over the business. The cabins are now charming apartments. (Courtesy of Ken Holtzclaw.)

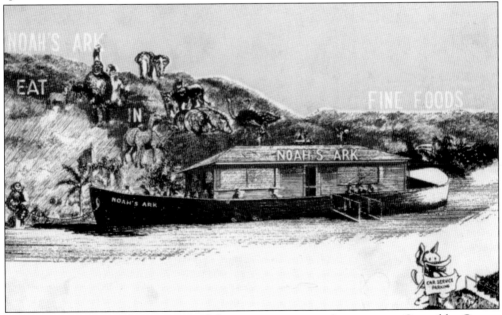

This period postcard illustrates one of the areas most unusual restaurants. Owned by George H. Herbert, Noah's Ark restaurant was located at the north end of Leucadia on the south side of the Batiquitos Lagoon and was a favorite tourist eatery until it closed in 1960. (Courtesy of Kristi Hawthorne.)

This photograph was taken at the bottom of Leucadia's Grand View stairway looking north. Interesting to note are the exposed central bluffs of this region, formed by the accumulation of mineral and organic sediments laid down by the Pacific Ocean during the last ice age. (Courtesy of Ken Holtzclaw.)

Throughout many years, this unique building located on North Highway 101 has operated as a "mom and pop" store with a restaurant on the lower floor. It was purchased around 40 years ago by Lan Lama of South Korea, who leased the building to Mahir Abou in 1994. The restaurant was discontinued when the floor plan was remodeled to accommodate a larger inventory. (Courtesy of Ken Holtzclaw.)

Six

PIONEER FARMERS

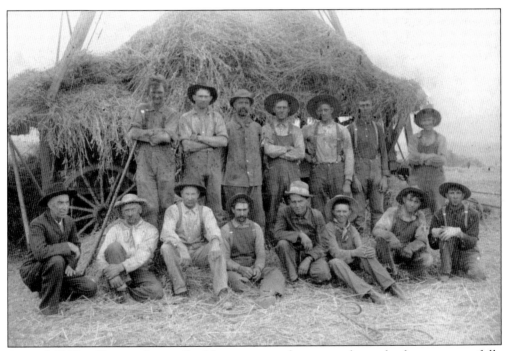

Around 1905, a Ventura farmer, Joe Vasa, came to the area and was the first to successfully grow beans on dry land. Farmers soon saw the potential for this crop, and by 1910, bean growing replaced corn as the principal crop. This undated photograph shows the bean harvest crew that worked the Wiegand Ranch. (Courtesy of the Scott family.)

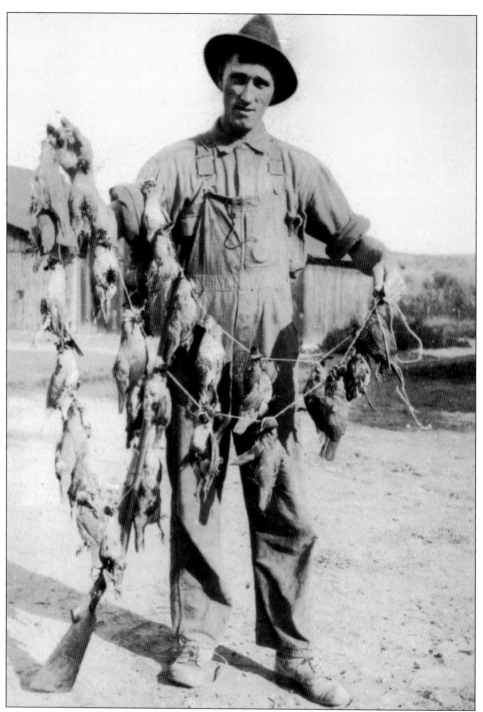

Bruno Denk, son of Olivenhain colonists Louis and Helene Denk, is seen here in this undated photograph with a string of quails, California's state bird. Settler Louis Denk, a cobbler by trade, turned to farming to make a living to support his children, Bruno, Alex, Ludwig, and Anna Marie. He became president of the Colony Olivenhain in 1888, serving a nine-year term. (Courtesy of the Denk family.)

The Denk family ranch is seen in this c. 1928 photograph. Located on Manchester Avenue, it was the home of Bruno Denk and Alwine Caroline Hauck, who married on February 26, 1918. Alwine was adopted as a baby by a childless couple, William and Caroline Fauth, when her own mother, Alwine Antonete Roben Hauck, died during her birth. (Courtesy of the Denk family.)

Little Harley Denk is framed by this coil of barbed wire held by his father, Bruno, and looked on by his brother Daniel. Farmers used the newly invented barbed wire to prevent free-roaming cattle from damaging crops. (Courtesy of the Denk family.)

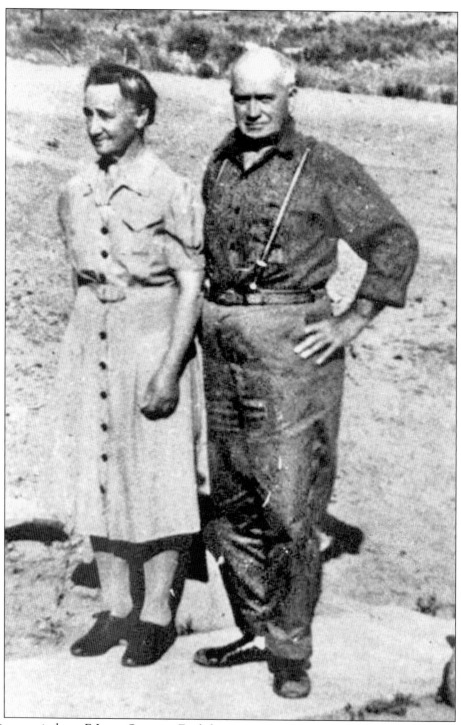

This portrait shows F. Lucas Scott, an English immigrant who settled Green Valley in 1919 with his wife, Lizzie, who was one of Adam and Christiana Wiegand's children. The 350 acres that comprised their farm, Oakview Ranch, became known as Scott Valley, located just east of El Camino Real. (Courtesy of the Scott family.)

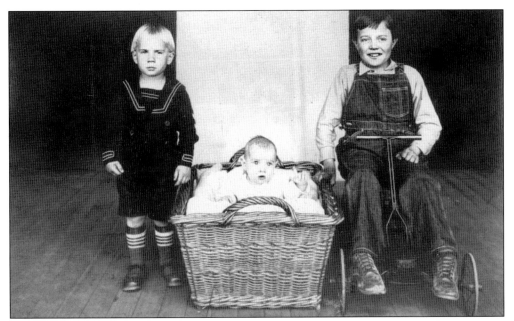

Lucas and Lizzie Scott had four children. Pictured, from left to right, in this 1924 photograph are George, Richard (the baby in the Moses basket), and Wayne. Tragically a baby sister died at birth. Known as "baby Scott," she is buried at the Olivenhain Cemetery along with other family descendants. (Courtesy of the Scott family.)

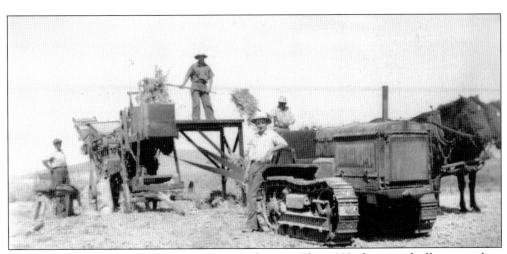

Threshing lima beans was always a communal event. This 1939 photograph illustrates that, although tractors relieved much of the burden of labor, horsepower and manpower were not yet obsolete. (Courtesy of the Scott family.)

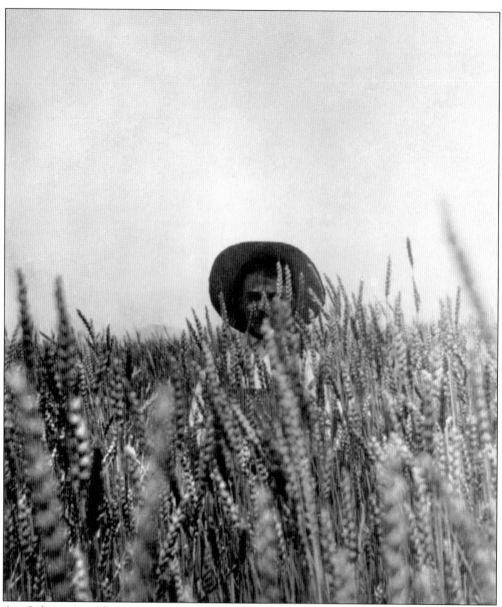

Art Cole is pictured as an adult in this fine stand of wheat. When he was a boy of 16, he earned extra money by opening a clay mine in Olivenhain with two older friends, Alex Reseck and Fritz Wiegand. They hauled out 50 tons of clay every day for several months. (Courtesy of Lynwood Cole.)

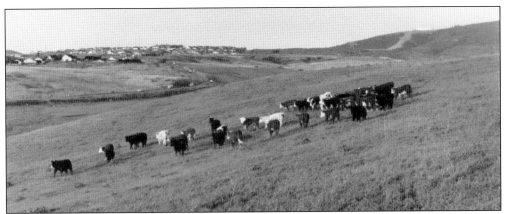

Art Cole's youngest son, Lynwood, loved his cattle. This panoramic view of Olivenhain shows the beginnings of residential development in the background and Lynwood's prized herd of cattle in the foreground. (Courtesy of Lynwood Cole.)

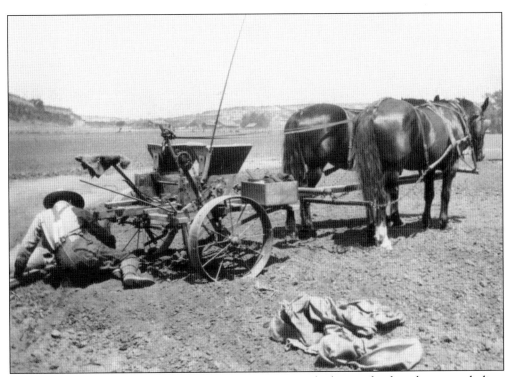

More than anything, this 1920s photograph of Bruno Denk planting his lima beans symbolizes the connection of man with the land. Bruno also played an important role in civic affairs. He served on the board for the San Dieguito Union High School District and was chairman of the Bean Grower's Association. (Courtesy of the Denk family.)

The cook shacks of the farming era provided food, a brief respite from the day's labors, and sometimes shelter. This 1915 photograph, taken by Lucas Scott, shows two of the cooks who provided healthy nourishment and brief social interaction for the toiling farmhands. (Courtesy of the Scott family.)

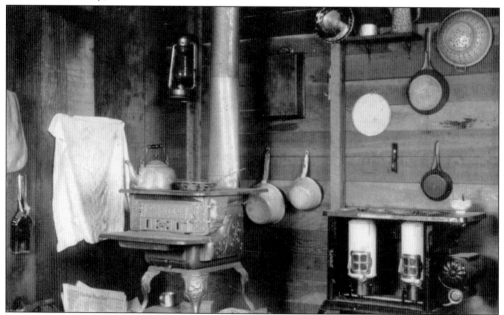

The interior of the cook shack, or cook wagon, shows two stoves—one wood burning and one that used kerosene. Pulled by a team of horses, plates and cups were secured during transportation in crates, which doubled as seating when the wagon was stationary. (Courtesy of the Scott family.)

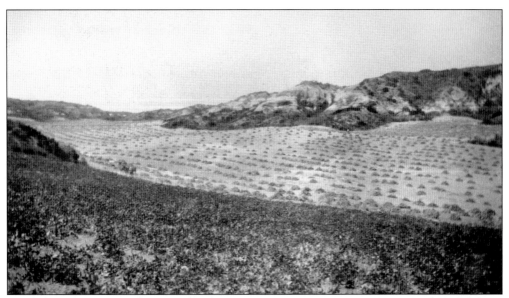

Lima bean farming was the lifeline of many local farmers. Through dry-farming methods, the bean plant needed little irrigation. This sweeping vista of lima beans shows Fish Canyon, southeast of Cardiff, named for the Fish family who originally settled there. (Courtesy of the Denk family.)

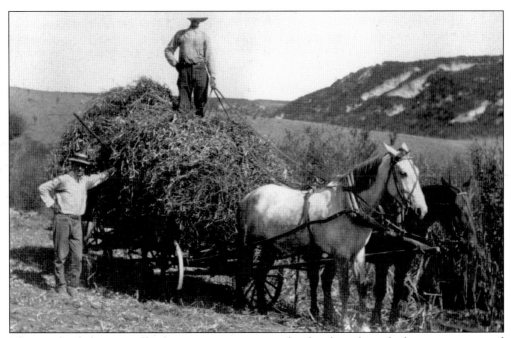

This overloaded wagon of beans is seen on its way to the thresher where the beans are separated from the vines. Average output could be up to 25,000 beans a day. Lima beans were planted in late April/early May and cut in late August/early September. (Courtesy of the Scott family.)

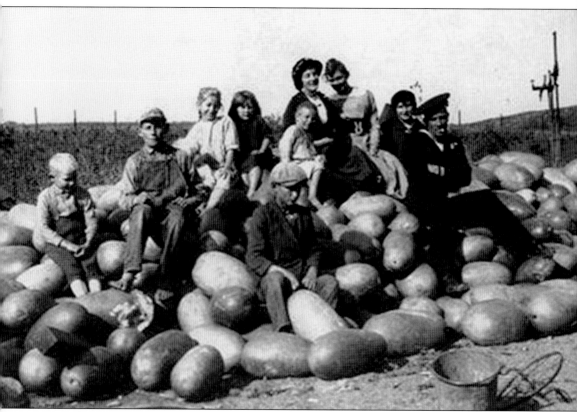

Lima beans, barley, wheat, oats, and corn may have been a farmer's principal crop, however, it can be seen in this Olivenhain farm photograph that watermelons grew there quite well too. Posed for this photograph is a group of farm children and young adults that appear to be quite proud of their crop. (Courtesy of Roger and Jeanette Teten.)

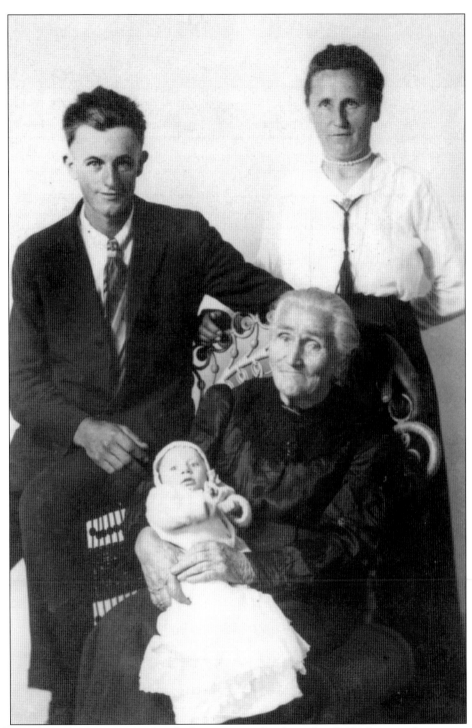

Alex and Amelia Lux, pictured with their growing family in this 1920 photograph, were one of the early pioneer families in the area. Herb Lux, their youngest son, still lives on two acres of their original 200-acre Cardiff homestead, a wedding gift from Amelia's parents, the Wiegands. It is now the site of Mira Costa College. (Courtesy of Lynwood Cole.)

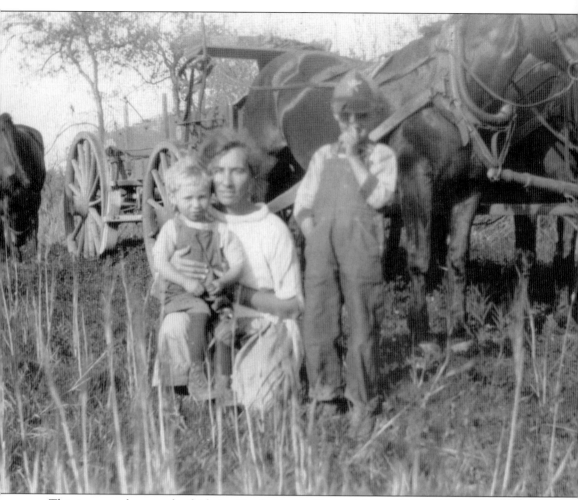

This is a rare photograph of Alwine Denk, pictured here with sons Daniel Herman and Harley Ludwig. June Shirley would be born later. Alwine, the self-appointed family photographer, captured the history of the Denk family. She barely went anywhere that she did not have her 35-millimeter Argus box camera with her. (Courtesy of Harley Denk.)

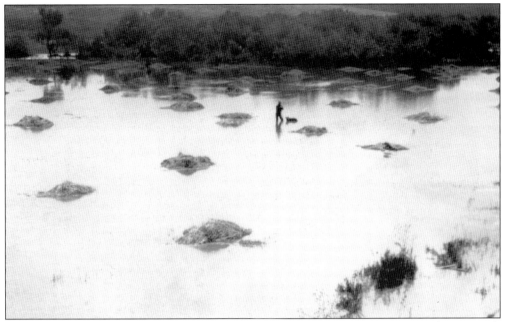

Weather was both a blessing and a nemesis of pioneer farmers. Bruno Denk, seen in the distance with his beloved dog Prince, is taking stock of the devastating damage caused by the 1930 flood, which destroyed his hay crop and washed most of it into the ocean. (Courtesy of Harley Denk.)

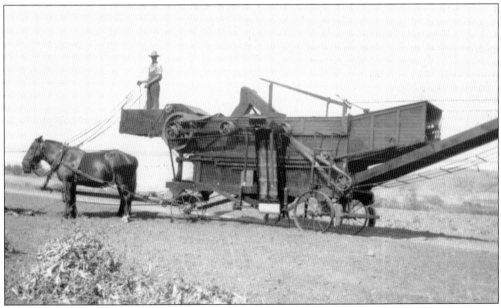

This huge threshing machine, made in Ventura and shipped by rail to Encinitas, was purchased by Bruno Denk around 1925. As tractors were not yet available to farmers, horses provided the power to move the machinery. Bruno Denk is pictured here driving them. (Courtesy of Harley Denk.)

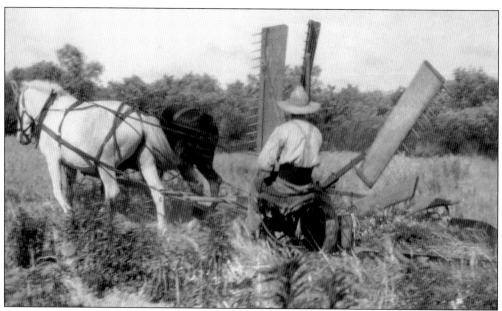

Alwine photographed Bruno Denk reaping barley. His Milwaukee reaper dates the photograph to around 1920. Bruno farmed his land from 1913 to 1965, at one point working 2,000 acres. Harley Denk, his youngest son, said in all that time farming there were only three years when they made a big profit. (Courtesy of Harley Denk.)

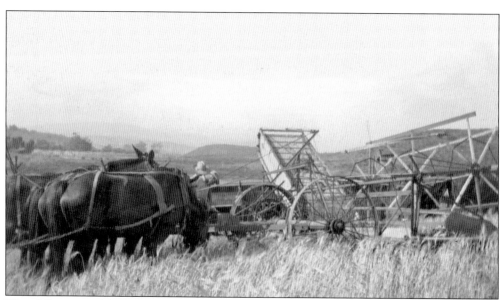

This idyllic scene of the barley harvest shows the sweeping open landscape unspoiled by development. By the mid-1960s, following the arrival of piped water, the community of Olivenhain was losing its farming identity. By the 1970s, residential housing development soared and there was an inevitable change in the face of the landscape. (Courtesy of Harley Denk.)

Seven

SURF'S UP

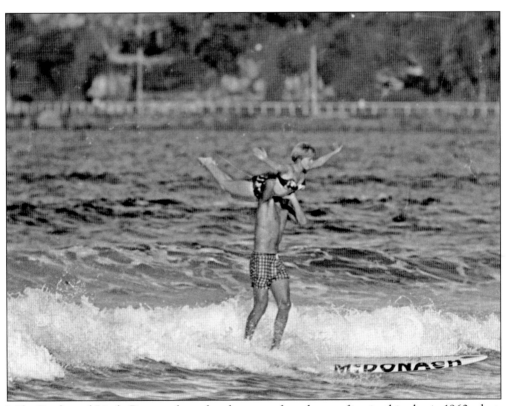

Mike Doyle and Linda Benson show the elegance of tandem surfing in this classic 1960s shot. Linda, a native Encinitan who currently lives in Solana Beach, has her own professional surf school for women, SurfHer. Classes are held in the summer at Moonlight Beach. (Courtesy of Linda Benson.)

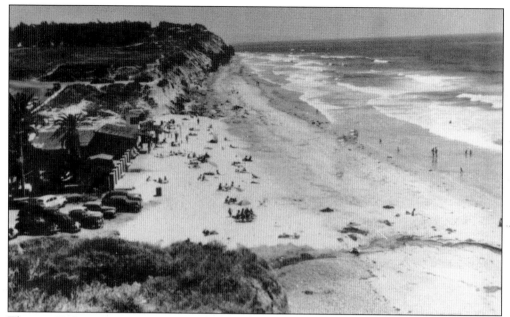

This is a 1940s vintage panoramic view of Moonlight Beach. Notable are the automobiles parked on the sand, the width of the sandy beach, and the absence of houses and condominiums on the bluff tops. (Courtesy of Quail Botanical Gardens.)

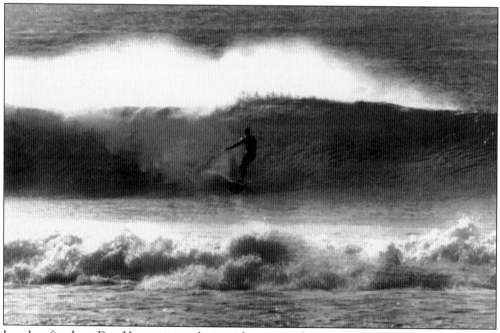

Local surfing hero Don Hansen is caught in mid-action in this *c.* 1960 classic surfing shot. Several beaches in Encinitas are famous for their premium surfing conditions, notably Cardiff Reef, Pipes, Beacons, Grandview, D Street, Stone Steps, and Swami's. (Courtesy of Don Hansen.)

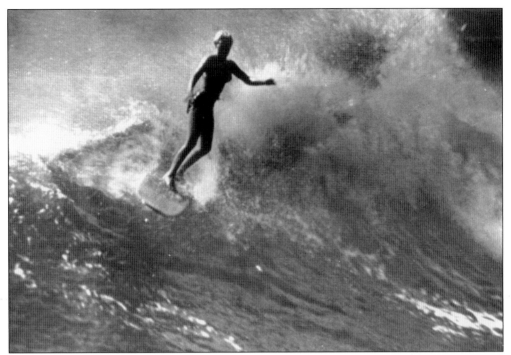

Mostly a male-dominated sport, Linda Benson was one of the first women to gain respect and recognition in the sport of surfing. Pictured here in Hawaii in the 1960s, Linda would prove her mettle by earning her position as world champion and five-time U.S. champion. She was inducted into the Surfing Hall of Fame. (Courtesy of Linda Benson.)

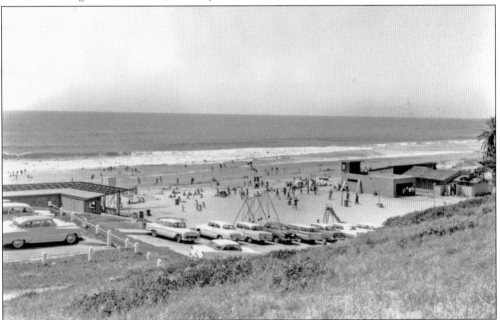

This photograph of Moonlight Beach in 1960 shows additional buildings that were constructed to the north and south of the children's play area. Probably the most visited beach in Encinitas, it still maintains its appeal for tourists and residents. (Courtesy of Linda Benson.)

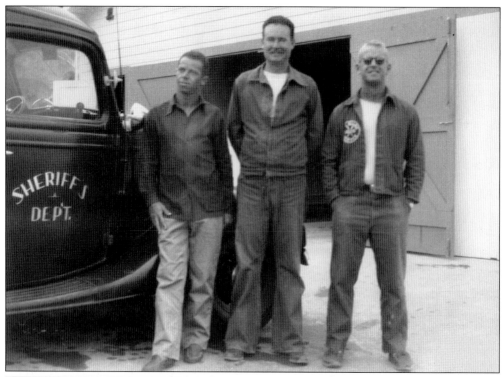

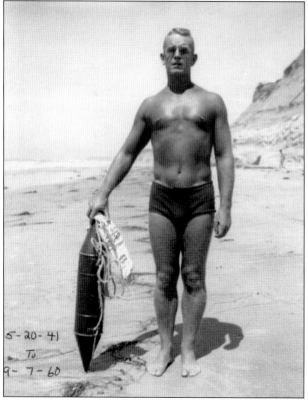

The County Lifeguard Service provided vital services to the north county beaches when it was established in 1941. This 1944 photograph, from left to right, shows John Rigon, John Brennan, and Capt. William Rumsey. Seed funds of $1,200 purchased the sole lifeguard service vehicle, which was fitted with wide tires for beach driving. (Courtesy of Solana Beach Lifeguard Department.)

This 1946 shot of Capt. William Rumsey was taken at Solana Beach where the lifeguard headquarters are located. Posing with the metal lifesaving "can," Rumsey became a legend when it was estimated that he had been responsible for saving 2,887 lives by his retirement in 1960. (Courtesy of Solana Beach Lifeguard Department.)

Kim Daun became a county lifeguard in 1946 when he was one of only four permanent lifeguards hired; a position he held for 14 years. This classic 1957 portrait at age 34 shows him posing with his lifesaving can. Kim, an ardent surfing enthusiast, surfed Sunset Cliffs in Ocean Beach during the 1940s before he moved to Del Mar with his wife, Betty. (Courtesy of Kim and Betty Daun.)

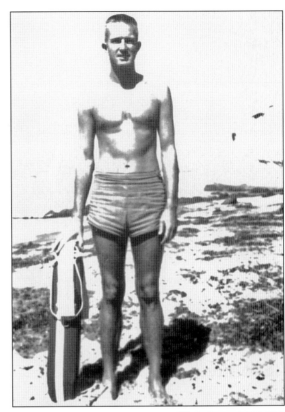

In 1940, Kim Daun posed with his surfing compadres. The original Sunset Cliffs surfers, the men remained friends and recreated this classic group portrait over 60 years later in 2003. Pictured, from left to right, are Kim Daun, Rob Nelson, Bill Sayles, Joe Tody, Lloyd Baker, and Bill "Hadji" Hein. (Courtesy of Kim and Betty Daun.)

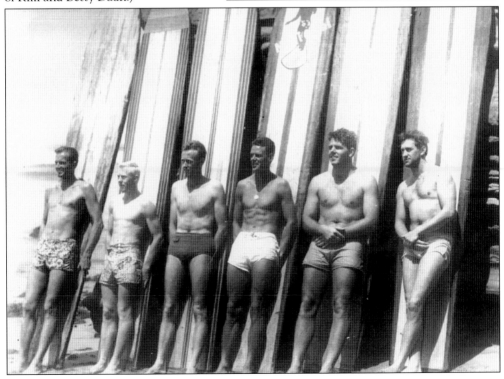

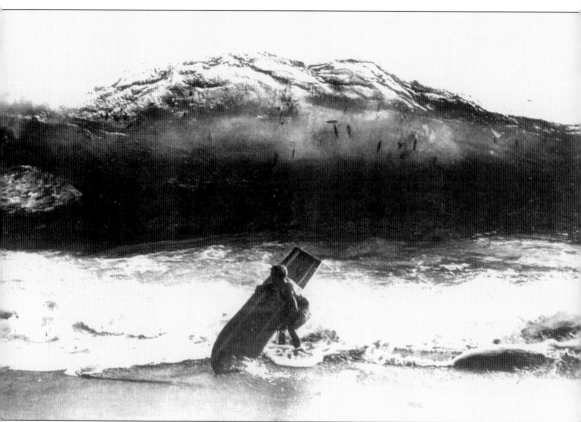

Leucadian Jack "Woody" Ekstrom, at 79 years of age, has made his mark over the decades as a surfing enthusiast and has earned his place as a local surfing legend. This 1940s dramatic photograph of a young surfer, struggling with a solid wooden longboard, was captured by Woody at a La Jolla beach. He used a custom-made box camera that belonged to his surfing buddy, Doc Bell, a dentist who traded a gold tooth for the camera's high-powered lens that came from a coroner's office in Los Angeles. Woody was recently featured in *Surfshot* magazine in a feature story, "Legends of San Diego County Surfing." (Courtesy of Woody Ekstrom.)

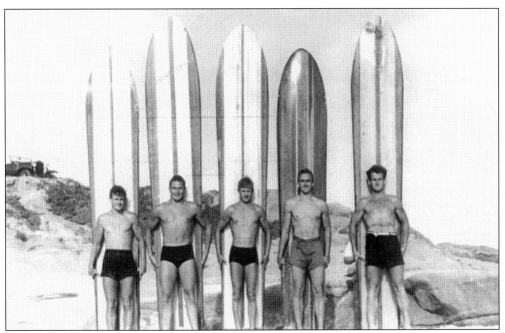

Hailing from La Jolla, Woody Ekstrom was captured in this 1946 photograph with his surfing buddies at Windansea. Pictured, from left to right, are Towny Cromwell, Buddy Hull, Woody Ekstrom, Bill Isenhower, and Andy Forshaw. Today Woody lives in the bluff-top home on Neptune Street in Leucadia that he purchased in 1960. It has spectacular panoramic ocean views. (Courtesy of Woody Ekstrom.)

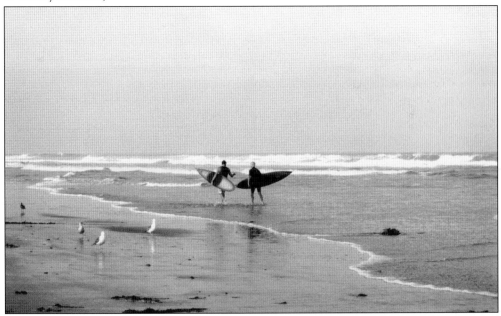

Surfing is exceptional on all of Encinitas's beaches, from Cardiff to Leucadia. Much has improved in surfboards and technique since local legend Jim Truax (the son of Ida May Noonan), born in 1926, began surfing as a 13-year-old boy at Swami's Beach. Reputed to be one of the first surfers in the area, he initially began catching waves on an ironing board. (Courtesy of Ken Holtzclaw.)

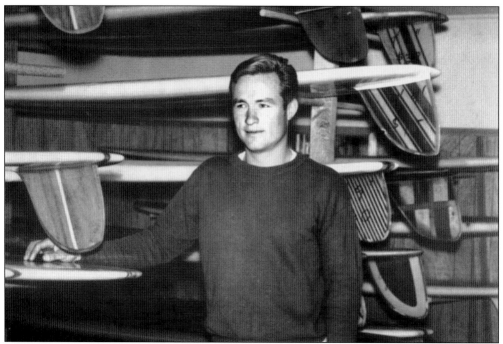

Don Hansen is pictured here in his surfboard shop in 1963. In 1965, he invited surfing champion Mike Doyle to work with him. Mike's surfing career exploded when he was voted "Best Surfer" by *Surfer* magazine readers in 1965 and 1966. Mike was nicknamed "Ironman" for his participation in surfing, tandem, and paddle races all in the same day. (Courtesy of Don Hansen.)

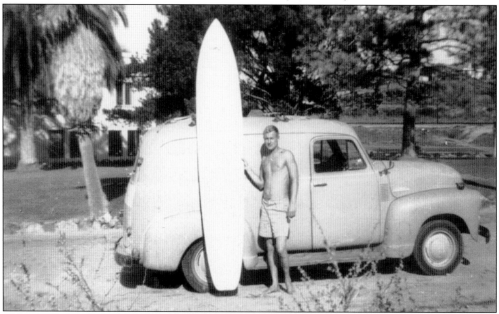

This classic photograph shows Don Hansen with his longboard and his 1949 Panel Chevrolet. His surfboards have become world renowned, and Don is a local celebrity who has supported the Hansen/Machado Surf Classic and Cardiff Beach Fair for over 10 years. His boards are now sold at his store, located at 1105 South Coast Highway 101 in Encinitas. (Courtesy of Don Hansen.)

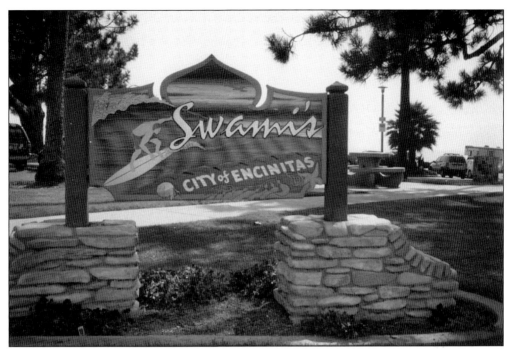

When James Noonan discovered Encinitas in 1888 during a stopover on a mining trip to Mexico, he came to a point on the bluffs that struck him by its breathtaking views. Noonan had his home built there by E. G. Hammond, and it became known as Noonan's Point. Today it is the site of the Self Realization Fellowship and is known as Swami's. (Courtesy of Ken Holtzclaw.)

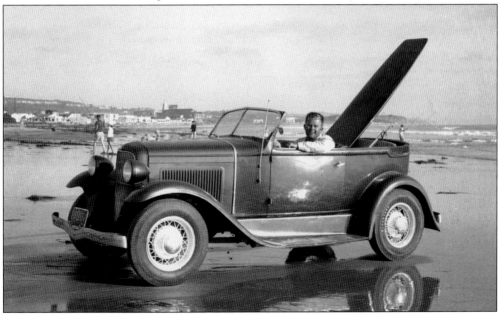

County lifeguard John Elwell patrolled the beaches from Seaside to Swami's in his 1932 souped-up Ford Phaeton. During his 10 years of lifeguarding, John had a spotless record. In the back of the car is a rare Bob Simmons surfboard and a French Arbelette speargun, standard lifeguard equipment in the 1950s. (Courtesy of John Elwell.)

"Woodies" have become synonymous with surf culture and the beach. This photograph captures the timeless elegance of Henry Traulsen's Woodie, a 1948 Ford super-deluxe station wagon. Henry is past president and current member of the San Diego Woodies, the local chapter of the National Woodie Club. (Courtesy of Henry Traulsen.)

The Wavecrest Woodie Meet takes place each September at Moonlight Beach. This year will celebrate the 27th meet, which originated in Del Mar and was organized by Stuart Resor. Today the San Diego Woodie Club presents the annual event, which attracts about 300 classic Woodies, making this the largest gathering of Woodies in the world. (Courtesy of Henry Traulsen.)

Eight

ENCINITAS PRESENT

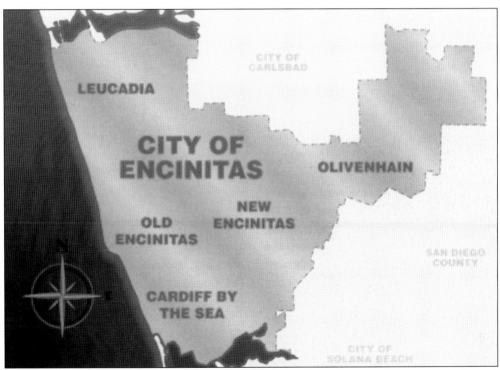

This map shows the location of the five communities that form the city of Encinitas. At Second Street the elevation is 92 feet, the city as a whole comprises a 19.4 square-mile area, and the annual average temperature is 72 degrees. The population is about 60,000, it has 163 miles of public streets, and it is located along six miles of Pacific coastline. (Courtesy of Directory and Maps USA.)

The city council for Encinitas consists of five members, elected on staggered four-year terms. They approve the city's financial and capital improvement plan and adopt goals and procedures that define services for residents. Pictured here are former Mayors Dan Dalager (left) and Maggie Houlihan. (Courtesy of City of Encinitas.)

The other members who complete the city council, pictured here, are Christy Guerin, the current mayor of Encinitas; Jerome stocks; and James Bond, the current deputy mayor. (Courtesy of City of Encinitas.)

The citizens of Encinitas care passionately about their city, symbolized in the combined efforts of the city council and community members in making their 20-year city-hood celebration a memorable one. This graphic illustration by Leucadian artist Fred Caldwell includes the 16 mayors who have served during this period. (Courtesy of Fred Caldwell.)

Fred Caldwell designed this montage of local scenes that was used for a commemorative calendar and on the cover for the Encinitas Chamber of Commerce's Visitor Guide and Business Directory. Inspired by Maxfield Parrish, it was initiated by the city's Cultural Tourism Committee, chaired by Maggie Houlihan and Dan Dalager. (Courtesy of Fred Caldwell.)

Named Myotokuji, this temple is a landmark in Encinitas's Japanese sister city, Amakusa. Although predominantly Christian, most Amakusans tend to be of multi-faith. A resident there might attend a Buddhist temple, get married in a Christian church, and have a Shinto ceremony at death. The area was named after Shiro Amakusa, the leader of the Christian rebellion. (Courtesy of Rick Shea.)

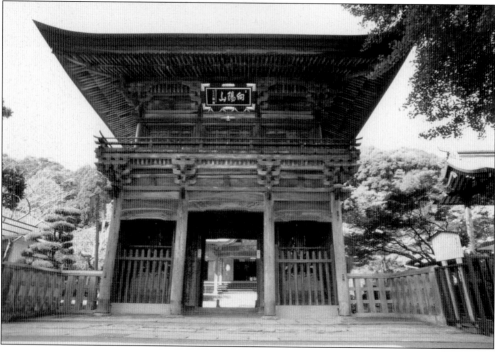

This photograph was taken at the Hondo International Triathlon in 2004. Now known as the Amakusa Triathlon, it is the oldest Olympic distance event in Japan. The photograph shows Ian Thompson, council member Maggie Houlihans's husband, who competed in the event. The triathlon was organized and designed by Jim Curl, a Del Mar resident. (Courtesy of Rick Shea.)

Encinitas is a member of Sister Cities International. Encinitas shares a sister-city relationship with Amakusa City, Japan (formerly named Hondo). This photograph of former Encinitas mayor Rick Shea and former Hondo mayor Yoshito Kuguyama was taken at the official signing in September 22, 1988. (Courtesy of Rick Shea.)

The Sister City Program enabled young members of Encinitas to visit Amakusa. Pictured here are students visiting the local Hondo Municipal Museum in 2005. The program was established in 1988 as an outgrowth of a major triathlon event. Since that time, the city has sent delegates of students, nurses, firefighters, leaders, and government officials to participate in and learn about Japanese culture. (Courtesy of Rick Shea.)

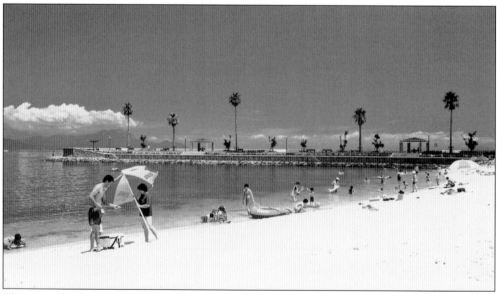

The unspoiled beauty of the pristine beach at Amakusa in Japan made it a perfect city partner for Encinitas. Formerly Mogine Beach, now called Hondo Beach, it is located on Shimo Island and is known by many Encinitans as the Japanese Moonlight Beach. (Courtesy of Rick Shea.)

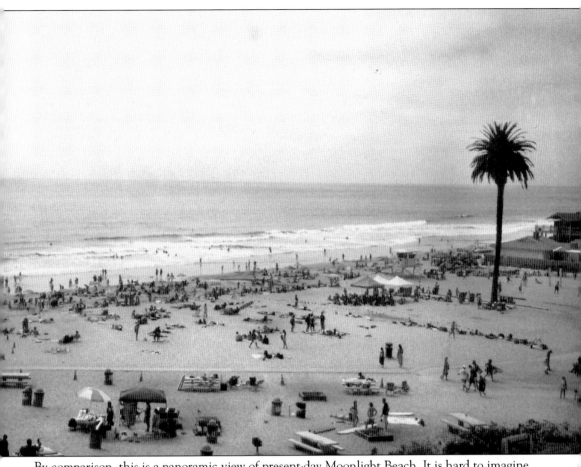

By comparison, this is a panoramic view of present-day Moonlight Beach. It is hard to imagine that the early female settlers would wash their clothes in nearby Cottonwood Creek. Turning this into a fun family event, they would picnic at the beach while their laundry dried on nearby shrubs. (Courtesy of Ken Holtzclaw.)

Dody Tucker, artist and co-owner of the Moonlight 7-11 store, was commissioned by Mike Andreen, publisher of *Encinitas First*, to create this graphic montage, a parody on the Beatles' *Sergeant Pepper's Lonely Heart Club Band* album. Comprising over 50 Encinitans' portraits, it provides a snapshot of the people, past and present, who have made their mark in Encinitas. Dody and her husband, Gary Tucker, have been an active part of the Encinitas community for over two decades. Gary is a former Encinitas Chamber of Commerce president and currently serves as treasurer on the board of the Downtown Encinitas Mainstreet Association, or DEMA as it is more commonly known. (Courtesy of Dody Tucker.)

A true living legend, Tony Hawk has brought skateboarding into the mainstream of American sports. He made skateboarding history when he landed the first-ever 900 (two and a half mid-air spins) at the X Games. Turning professional at age 14, Tony, a graduate of Torrey Pines High School, retired from competitive skateboarding at age 31. (Photograph by Grant Brittain; courtesy of Tony Hawk.)

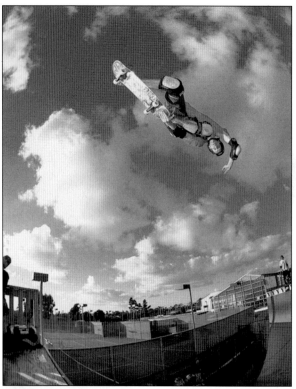

This skate shot of Tony Hawk, considered by many to be the greatest skater in the history of the sport, was taken in 2000 at the newly opened Skateboard Park at the Magdalena Ecke YMCA. Tony has a foundation designed to promote and help finance public skate parks in low-income areas. His foundation has distributed more than $1 million to date. (Photograph by Grant Brittain; courtesy of Tony Hawk.)

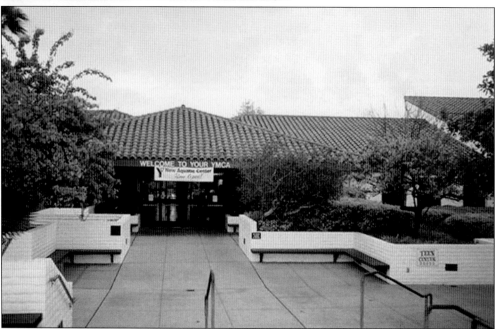

This photograph shows the entrance of the Magdalena Ecke YMCA, located on Saxony Road across from the Paul Ecke Ranch. Owned by the Eckes, this land was donated to facilitate the construction of the "Y." The farmhouse of the Sugimoto family, local Japanese farmers who grew fruits and vegetables, once stood here. (Courtesy of Ken Holtzclaw.)

Pictured here is the complex of the Encinitas Community and Senior Center. Two highly contentious projects, the building of the Home Depot and the development of the Encinitas Ranch shopping center, which ultimately won approval by the voters, funded the construction of the center. (Courtesy of Ken Holtzclaw.)

This neighborhood park, located on Willowhaven Road, is named for the Scott family who once farmed this area when it was known as Green Valley. At age 82, Richard Scott, the youngest son, has been providing rainfall measurements to the San Diego County Department of Public Works for about 58 years, a job he inherited from his father, F. Lucas Scott, in 1948. (Courtesy of Ken Holtzclaw.)

The Home Depot is located at the intersection of Olivenhain Road and El Camino Real on land that was bought for $10 an acre in 1915 by English settler F. Lucas Scott, who cultivated lima beans and wheat. His youngest son, Richard Scott, still lives in his home on part of the Oakview Ranch site, which looks down on the Home Depot. (Courtesy of Ken Holtzclaw.)

Queen Eileen's gift-basket store and the 101 Diner are just two of the businesses along South Coast Highway 101 that represent both the past and the present. Purchased over three years ago by Scott Smith, the 101 Diner's interior harkens back to the 1950s. Eileen Burke, owner of Queen Eileen's, offers nostalgic giftware that features the glory years of the surfing and beach culture. (Courtesy of Scott Smith.)

On March 24, 1969, Mark Anderson, at age 24, opened Anderson's Stationers on Second Street, having purchased the business from Gerry Montgomery. He subsequently built a new store at 700 Second Street, which he manages today. Pictured here, from left to right, are David Allen, Shelley Penza, Jim Werth, Mark Anderson, and Mike Spartley. (Courtesy of Mark Anderson.)

Pictured here is the Seaside Bazaar, next to the La Paloma Theater. It was launched as Peddler's Village in Leucadia by Sam and Irene Phillips and then held on land next to the log cabins on North Highway 101, where it was known as the flea market. It closed when the Pacifica Condominiums were built. Later it moved to Solana Beach before relocating to its present site in 1987. (Courtesy of Ken Holtzclaw.)

BIBLIOGRAPHY

Bumann, Richard. *Colony Olivenhain*. Self published, 1981.

Cozens, Annie. *Brief History of Encinitas*. Originally published in the *Encinitas Coast Dispatch*.

Dutter, Vera E. *Poinsettia King*. Paul Ecke Sr., 1975.

Encinitas Chamber of Commerce. *Encinitas Magazine*. August 1992, April 1993, August 1994.

Haskett, Wendy. *Backward Glances. Volume 1*. Self published, 2002.

———*Vol. 2*. Self published, 2004.

———*Vol. 3*. Self published, 2005.

Melvin, Robert. *Profiles in Flowers*. Paul Ecke Ranch Press, 1989.

Nelson, Jim. *Early Solana Beach*. Self Published, 2002.

San Diego Union. San Diego, CA. Various dates.

San Dieguito Citizen. Solana Beach, CA. Historic Edition, 1977.

Surfshot. San Diego, CA. March 2005.

Wiegand, Maura Harvey. *San Dieguito Heritage*. Self published, 1993.

INDEX

ACROSS AMERICA, PEOPLE ARE DISCOVERING
SOMETHING WONDERFUL. THEIR HERITAGE.

Arcadia Publishing is the leading local history publisher in the United States.
With more than 3,000 titles in print and hundreds of new titles released every
year, Arcadia has extensive specialized experience chronicling the history of
communities and celebrating America's hidden stories, bringing to life the people,
places, and events from the past. To discover the history of other communities
across the nation, please visit:

www.arcadiapublishing.com

Customized search tools allow you to find regional history books about the town
where you grew up, the cities where your friends and family live, the town where
your parents met, or even that retirement spot you've been dreaming about.